Stickers.

from the first international sticker awards

Title

Stickers.

...from the first international sticker awards – an introduction by Andreas Ullrich

When passing through our urban surroundings there is a tiny colored phenomenon visible on surfaces like spouts, windows, doorways, toilets, public transport, etc.– somehow stickers have always been there and are a little more than small notes. So whats the big deal about that?

It seems that urban communication has seen a shift in responsibility: after years of occupation of our cities by huge commerical advertising campaigns resulting in a pictorial flood of billboards, ever-present sponsoring of communal and public facilities and so on, the corporates seemed to have won the fight for the urban decoration and logoization of our everyday life. Young activists all over the world learned how easy it is to create their own signs and logos which are able to subvert the existing semiotic system by using the known signs, changing them and putting them into a new context – the context of education (in the meaning of Kants Aufklärung) and appropriation. The urban semiotic system is no longer a hierarchical system of guidance through a consumeristic cosmos promising happiness, love, fulfillment and enlightenment by buying characterless fetishes of mass production. It has changed from an emitter-acceptor principle to an open, democratised playground – a world that is ready for your comment.

This change is very minor in size indeed compared to large ad-campaings, but the turn to be willing to participate in the decoration and interpretation of our everyday surroundings and not to leave it to the global players is done. However, those comments may look like political statements, illustrations, logo reinterpretations, quotations and uninterpretable signs – they are all traces of individual forms of communication, an intersubjective communication in public space. And this game is not one-way communication. It reacts to the specific premises of the given situation and after the graphic intervention is placed, it leaves a constructed situation for the other residents to pass by and react.

We know the movement called graffiti, but unlike graffiti these infantile little stickers don´t have the gesture of destruction inherent in their form - rather the gesture of connotation and satiric annotation. Those interventions are much more representative for a critical mind seeking to contribute to the social urban interexchange anonymously, without doubting the principle of defacing private property.

At rebelart.net and stickma.de we had our eyes on these pin pricks in public space for several years now and started like everyone else by trying out our comments and ideas in the urban context. Over the years, our understanding grew that our activities are not so individual at all. All the places we went to showed the same phenomena and the number of interventions grew larger and larger over the last few years. Urban sticker activity is nearly a mainstream sport today and could even be called urban gardening. A nice hobby that brings out flowering structures from the grey urban reality with a sense of ludic delight – everywhere from Australia to South America.

Prolog

The most astonishing fact we found was that this form of iconic intervention exists worldwide. Like two peas in a pod, no matter if you look at Singapore, Hamburg or Caracas, the urban surroundings with their equal logos and globalized aesthetics brought about an equal kind of reaction in formal and intentional respects alike. In realizing this, we decided to professionalize our ambitions and to print, publish and exhibit various artists from all over the world in this specific and mainly undocumented, fastly vanishing medium. Today at Wildsmile Studios in Germany, we produce a approximatly 300.000 stickers a month, hosting lots of free print runs for small and sticky artistic interventions and able to focus on an international level with the various urban playgrounds all over the world. And thus the reason for founding the international sticker awards. We think this is the best way to encourage artists in proceeding with their mostly anonymous work for which they get only very limited credit, and to inform others about the different possibilities and actions being taken to participate in the urban semiotic interexchange. The first international sticker awards was launched on www.stickeraward.net on January 21, 2005 and accepted submissions until May 31, 2005. With nothing more than word of mouth within the network of sticker artists worldwide, there were over 2,500 submissions of graphics and photos from over 1000 different artists. This book is the documentation of those submissions and therefore all the pictures in this book have been printed in their original quality. We have selected about 800 works that represent today´s approach to reclaim public space. In order to find the most convincing ideas and concepts of intervening in public space, we asked a couple of colleagues who are working like us in the field of culture jamming (as Naomi Klein puts it) and enhancing urban, alternative development to help us to judge the thousands of works. Those colleagues and jurors were:

Edmar Marzewski
Chief Editor of Lumpen magazine and host of Versionfest and SelectMedia Festival based in Chicago, USA
www.lumpen.com

Chris Sauve
Editor and Graphic Designer at Adbusters Magazine, Vancouver, Canada
www.adbusters.org

Dom Murphy
Initiator and Host of the worlds largest online archive of sticker works, stickernation.net, Birmigham, England
www.stickernation.net

Oliver Vodeb
Host and Founder of MEMEFest, Festival for radical communication, Ljubljana, Slovenia
www.memefest.org

Alain Bieber
Chief Editor of Rebelart Magazine and Curator, Berlin, Germany
www.rebelart.net

Our first prize went out to Carla_Ly from Caracas, Venezuela, who reached the highest point ranking from our jurors and even made it to Berlin in July 2005 for the award ceremony. The results of the first international sticker awards and symposium on sticker culture were presented in the "The ABC – semiotics of resistance" exhibition in Berlin´s notorious Neurotitan Gallery in July 2005, organized by Alain Bieber and Andreas Ullrich. It featured besides the sticker awards project works of the intermedia artists 0100101110101101.org, Hans Bernhard (ubermorgen.com), Heidi Cody, Erosie, Influenza, Matt Siber and many more.
>>> www.the-abc.org.
We will continue to focus on the collection of international stickers and want to encourage you with this publication to take action yourself by making your everyday surrounding into one that suits you best and one that represents you and your individual ideas at the highest level. No compromises.

Thanks again to Die Gestalten Verlag and their Chief Editor Robert Klanten without whom this publication would have never been possible. Send us your results. The next sticker awards will open for submissions in June 2006. Thanks again to everyone who took part in the competition and who helped us getting so far,

Keep up the good work.

Prolog

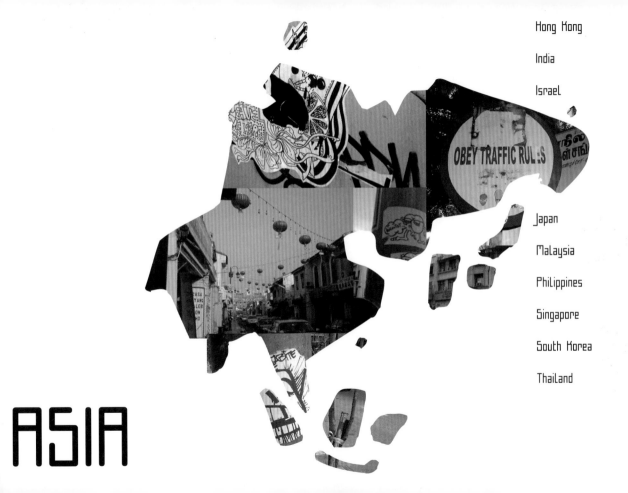

ASIA

Hong Kong

India

Israel

Japan

Malaysia

Philippines

Singapore

South Korea

Thailand

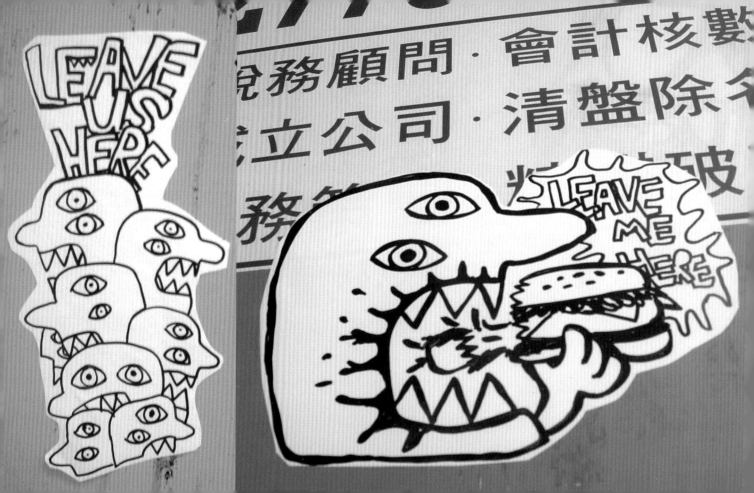

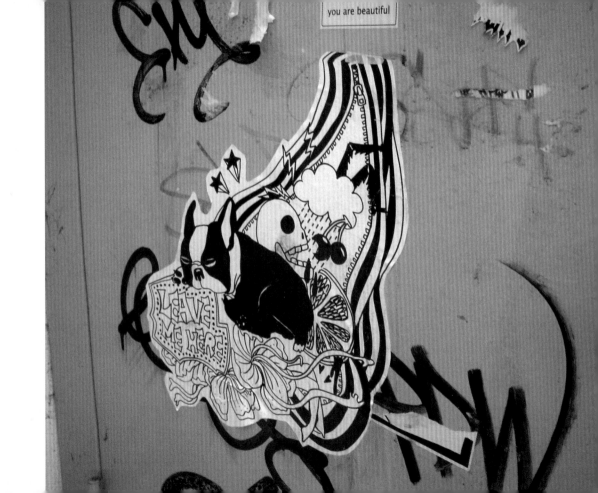

you are beautiful

graphicairlines l Hong Kong

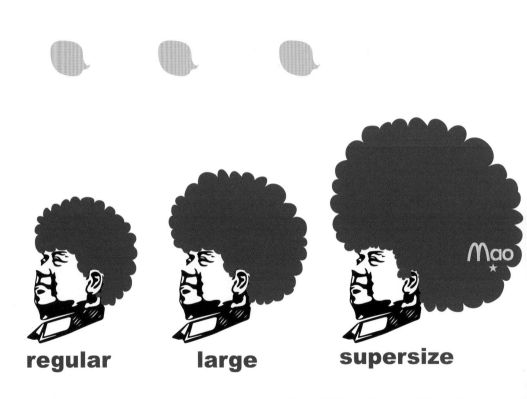

regular **large** **supersize**

David lhuillery ll graphicairlines | Hong Kong

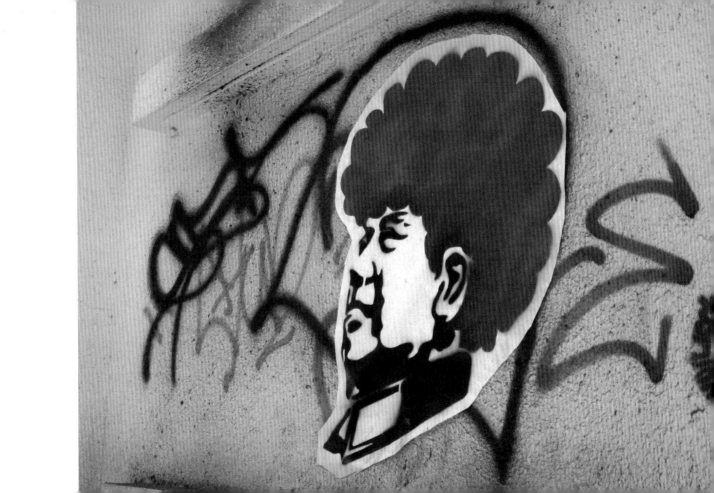

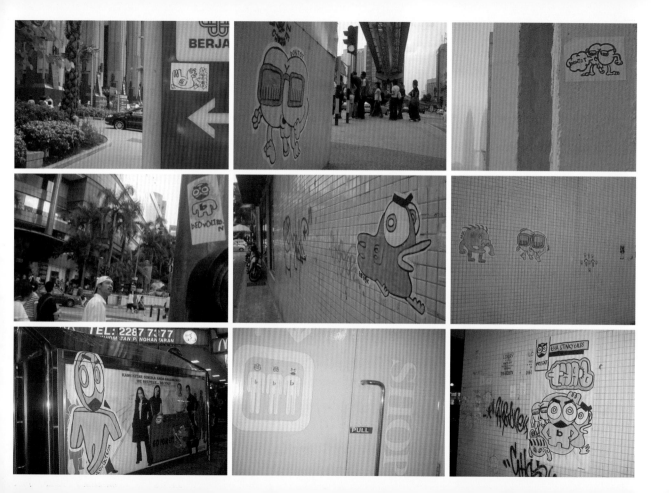

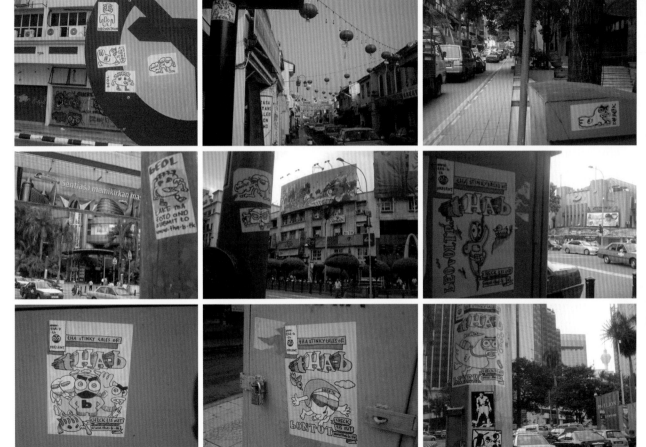

tha-b | Malaysia

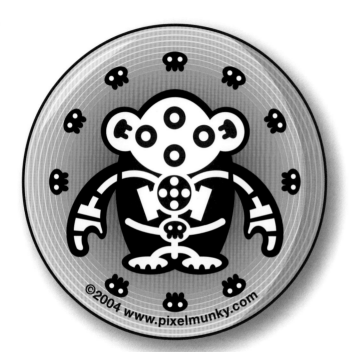

© 2004 www.pixelmunky.com

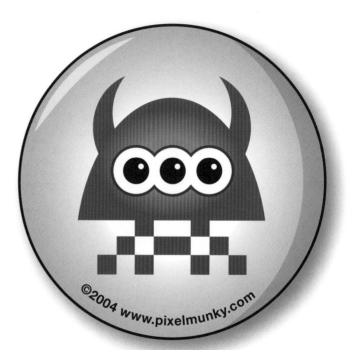

© 2004 www.pixelmunky.com

Pixelmunky | Singapore

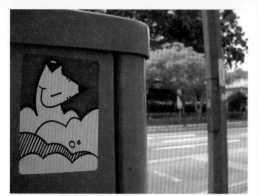
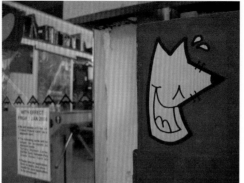
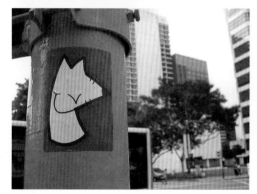
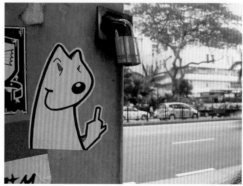

The Killer Gerb | Singapore

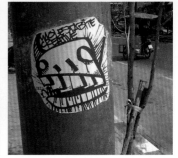

"Something strange happening in this village"
THE RAW ONES

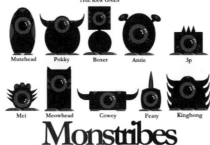

Mutehead Pokky Boxer Antie 3p

Mei Meowhead Cowey Featy Kinghong

Monstribes
by Funkbuilders

Nick B. ll Roger Tan I Thailand

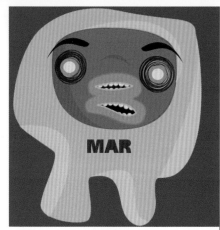

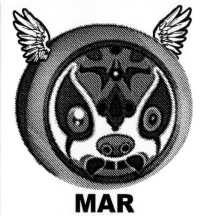

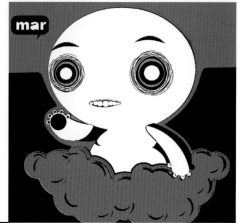

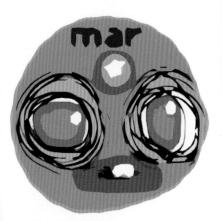

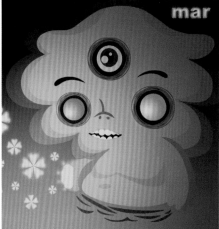

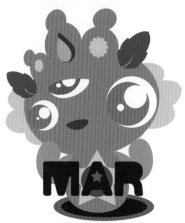

Mar | ThaiLand

BUY THE LIE
DEFORMINDUSTRY

eat you

n ice to m too!

DE4MNDS3

DeFormindustry I Philippines

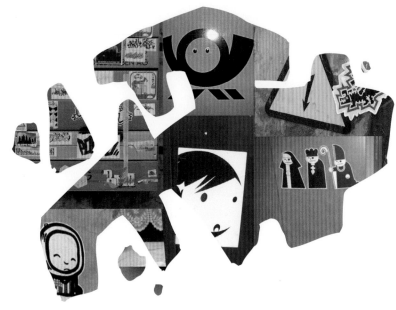

EUROPE

Austria
Belgium
Croatia
Denmark
Estonia
Finland
France
Germany
Hungary
Italy
Lithuania
Netherlands
Poland
Portugal
Romania
Russia
Slovakia
Slovenia
Spain
Sweden
Switzerland
U.K.
Ukraine

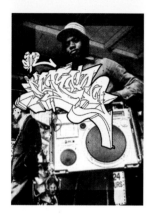

THIS THING

is **useless, exploitative** and it simply **sucks**

avoid ...

Ed 1 | Austria

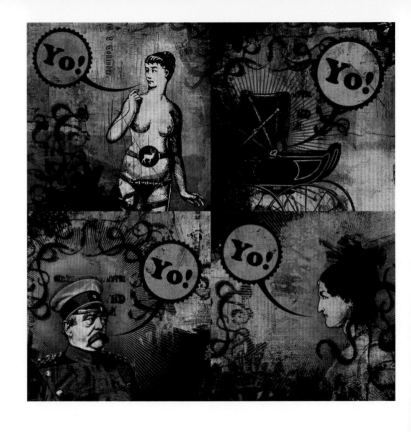

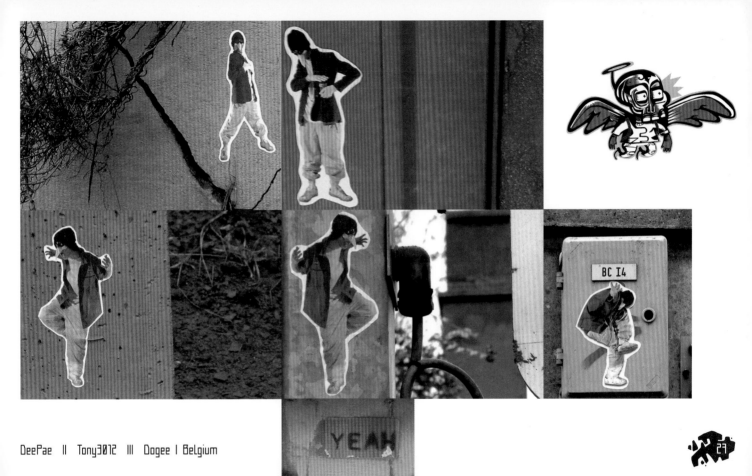

DeePae || Tony3012 ||| Dogee | Belgium

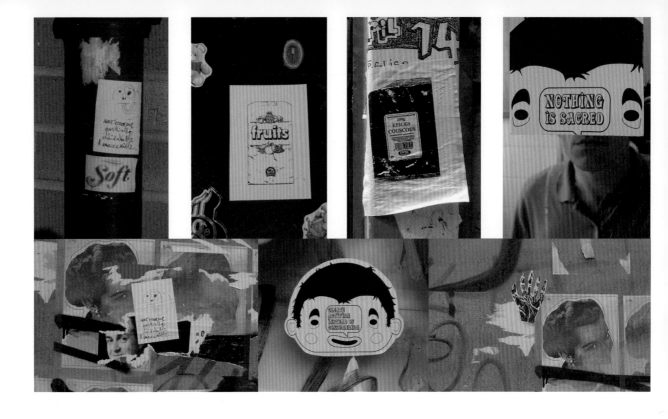

KYB | France

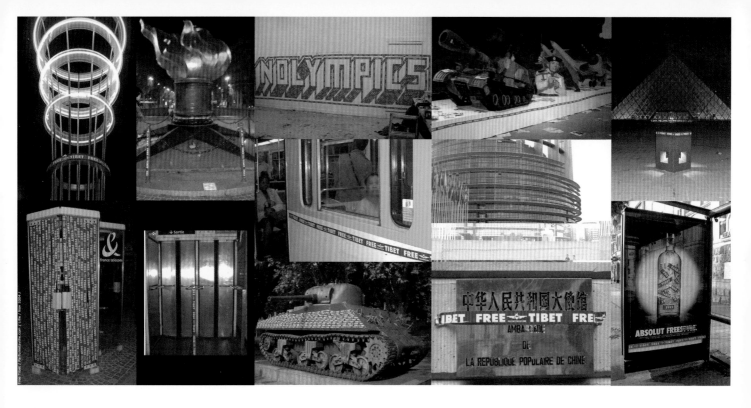

Joris Bacquet || Tama Bulsara | France

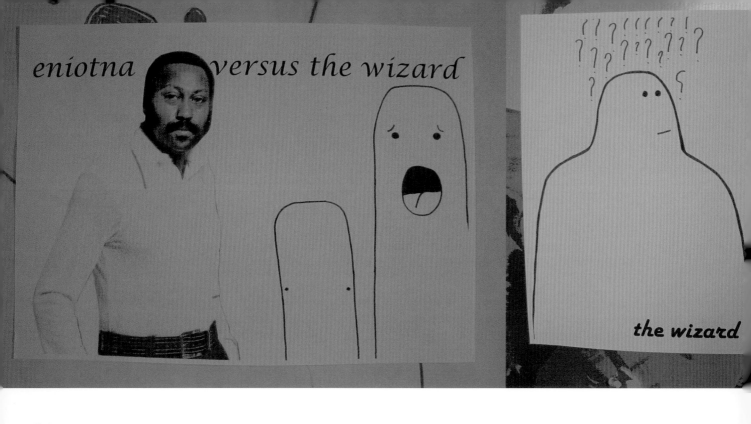

Eniotna+The Wiz I France

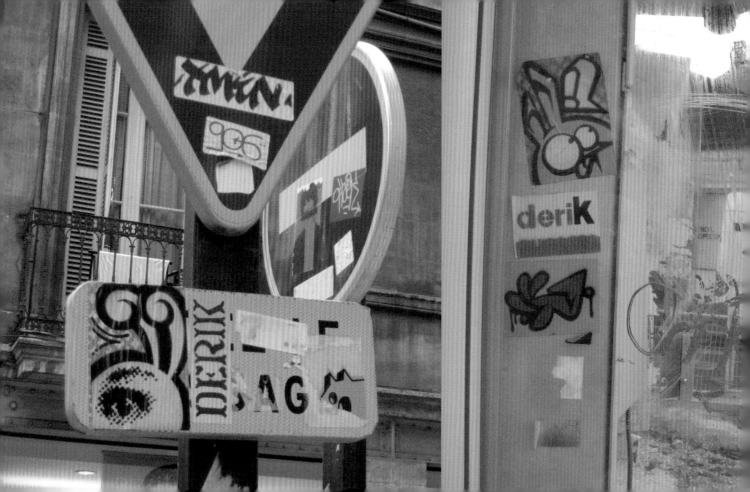

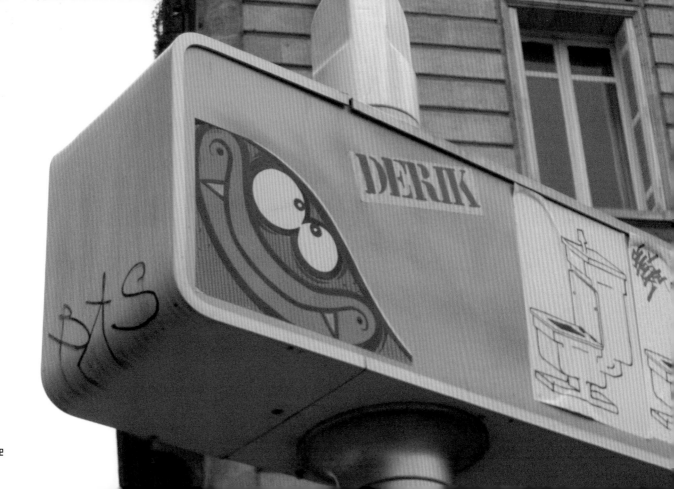

Derik | France

STICK**ME**
BABY !

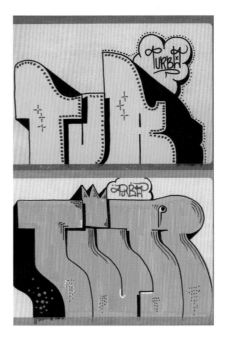

 36

Pirik ll Turbo lll bRog llll La Yeah! Prod l France

StiouP II Capish III Anne I France

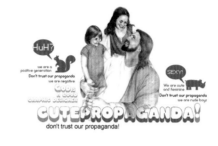

don't trust our propaganda!

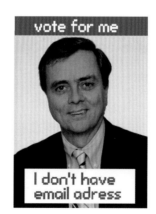

We do the best graphics
in the whole world

Don't trust our propaganda
we do shit

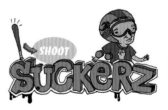

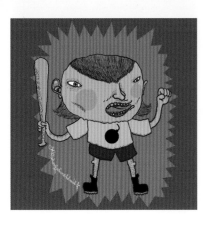

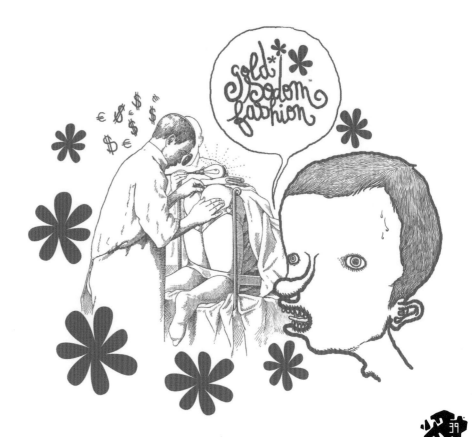

Lysian | France

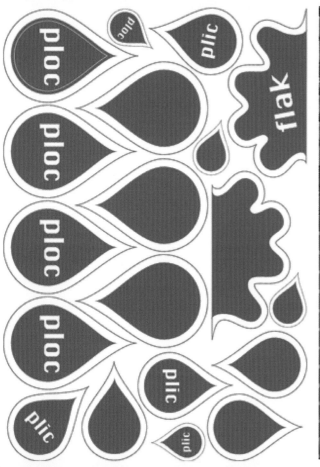

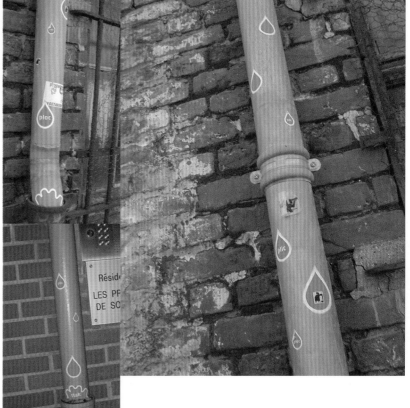

K I France

Girl21 | France

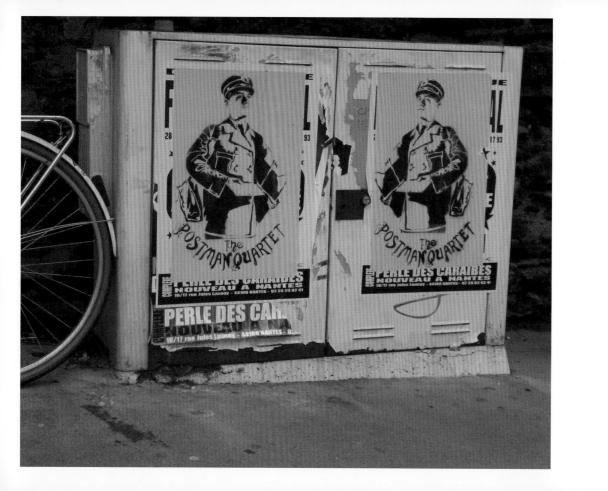

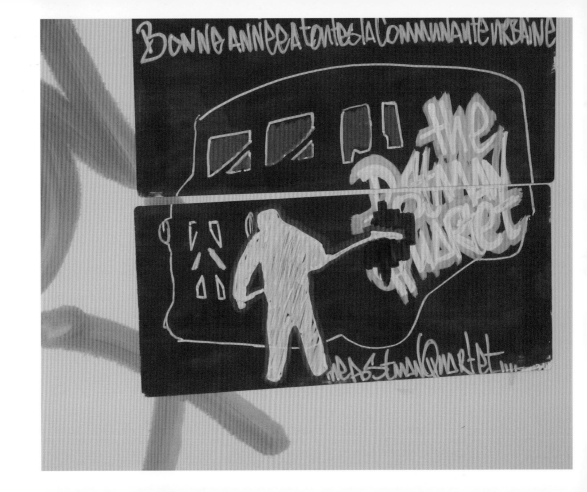

Postmanquartet | France

Turbo || Stiouf | France

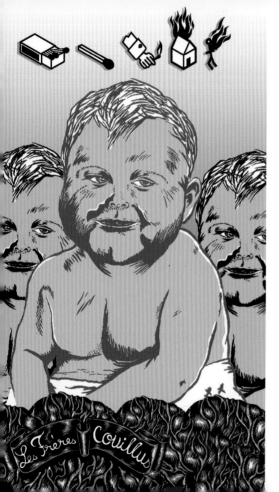

Dave Guedin ‖ Goin ‖‖ StickyLou | France ➤

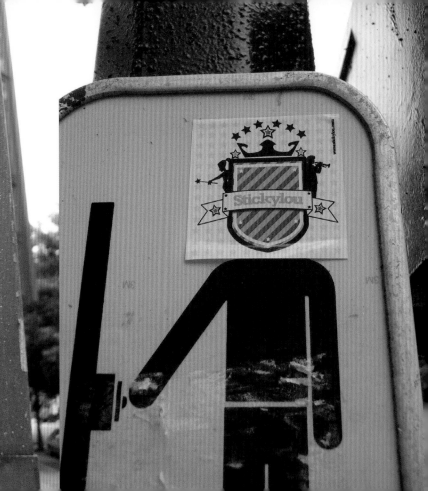

"YOU DON'T KNOW
WHAT
♥ IS
UNTIL YOU KNOW THE
MEANING OF THE
BLUES"

www.stickylou.com

Stickylou

www.stickylou.com

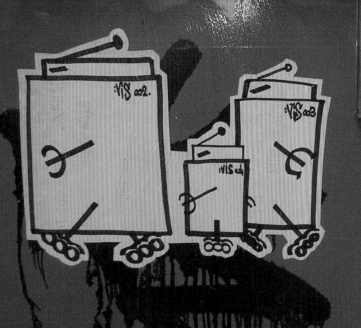

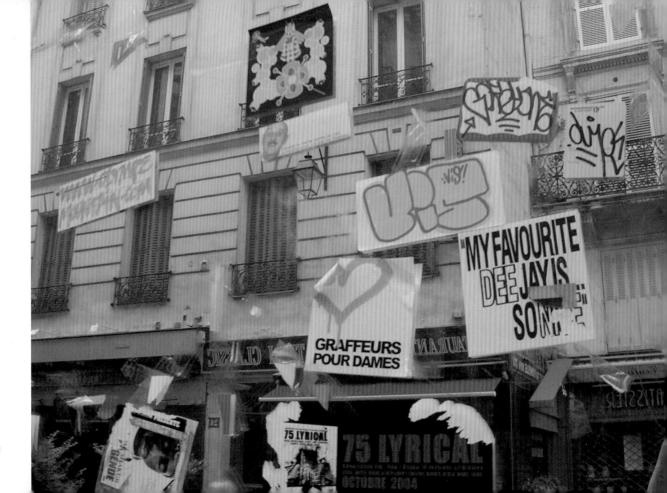

Vis!... | France

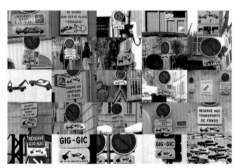
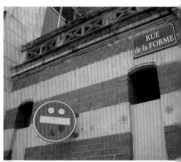

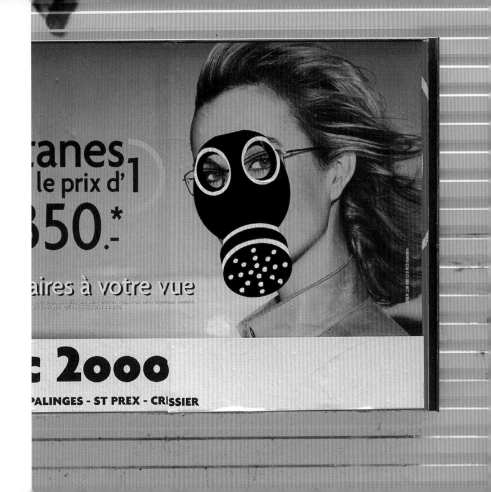

Jul33 | France

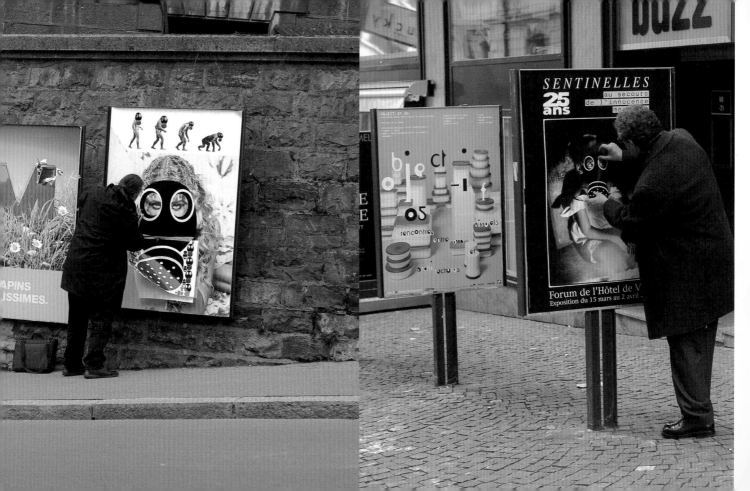

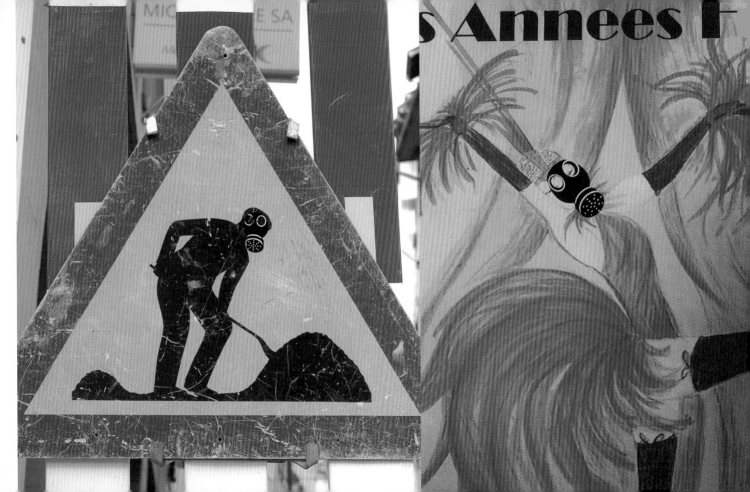

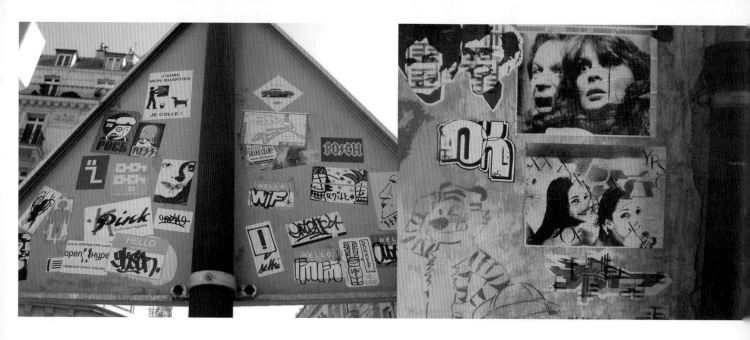

Yksor ll Ypso l France

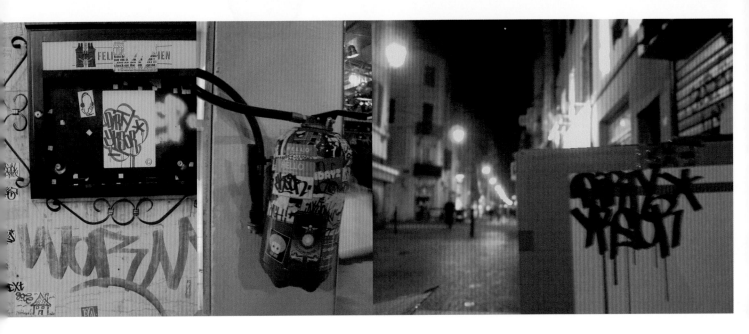

Yksor | France

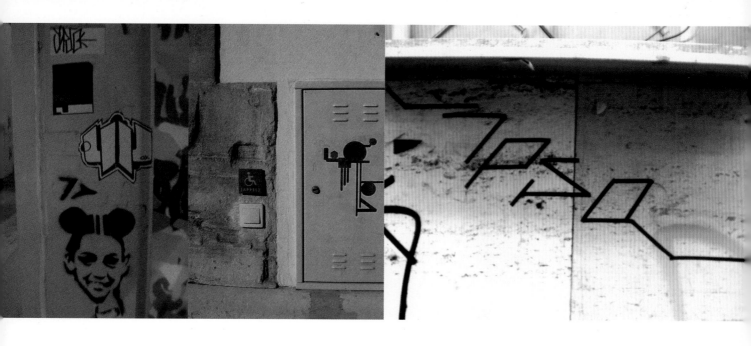

Ypso | France

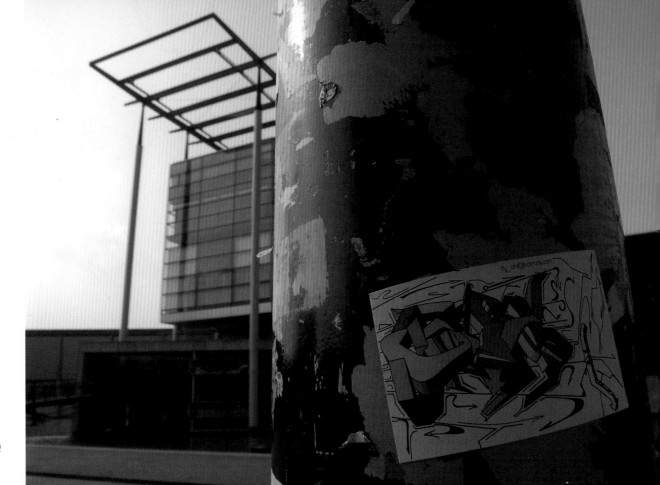

Olivier | France

BOROUGH OF **ISLINGTON**

I ♥

TM **MY**
BRAND

SAY IT!
THE MY BRAND PROJECT
WWW.MY-BRAND.COM

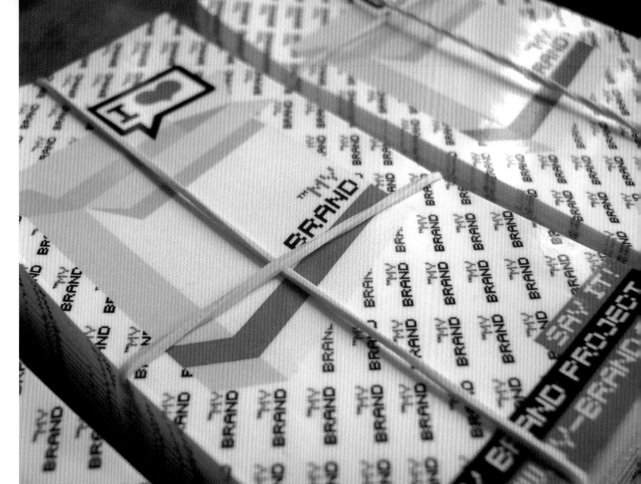

My Brand | France

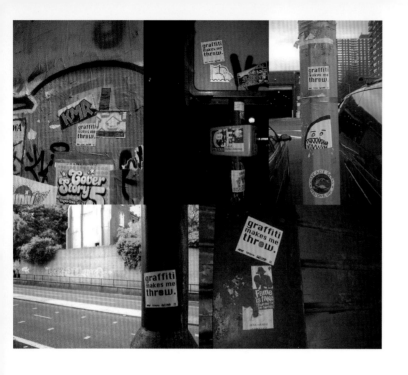

graffiti
makes me
throw.

Capish | France

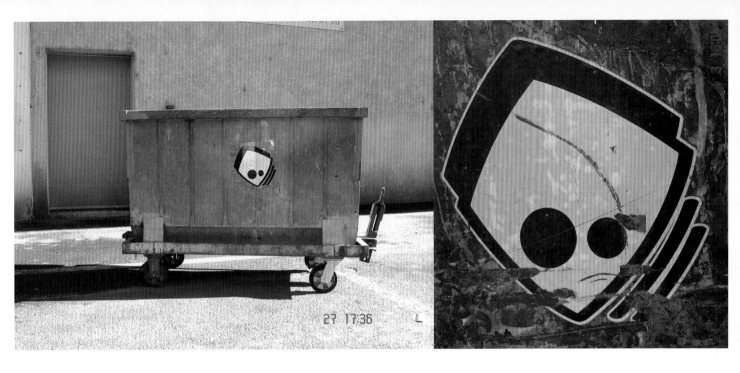

Cre | France

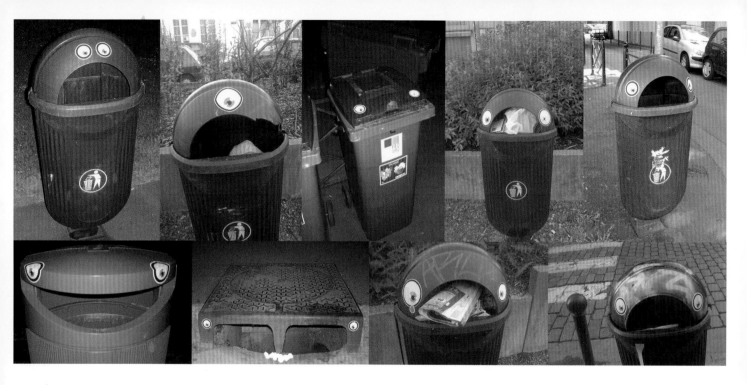

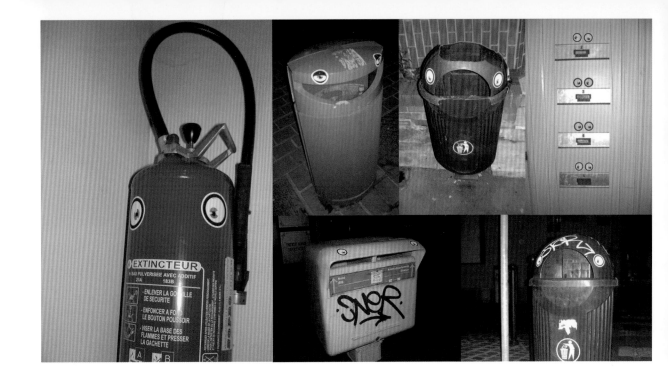

PPePPer | France

DRAW YOUR HEAD HERE

PUT YOUR MOTHER FUCKIN HEAD HERE

STICK YOUR HEAD HERE

GRAFF YOUR HEAD HERE

PAINT YOUR HEAD HERE

TAG YOUR HEAD HERE

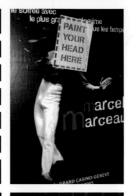

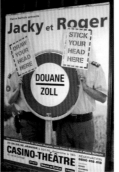

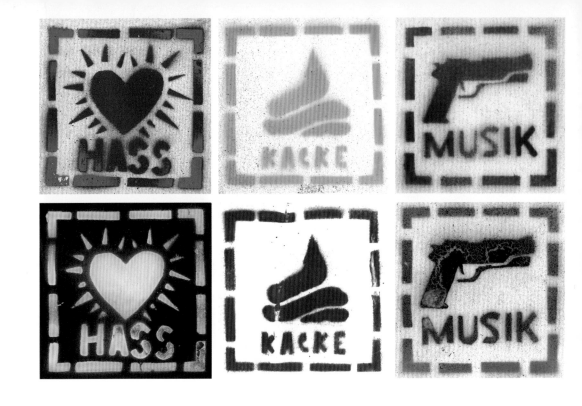

robaere | Germany

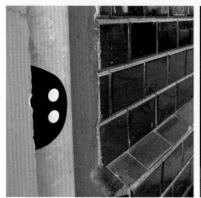 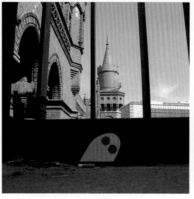

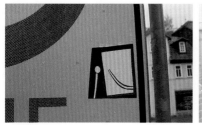

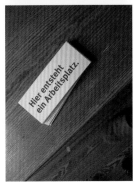

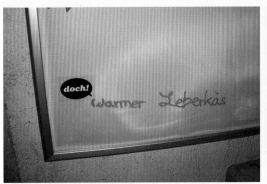

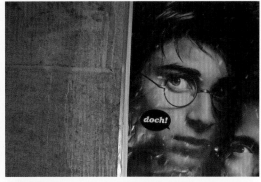

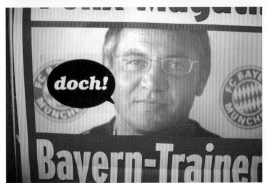

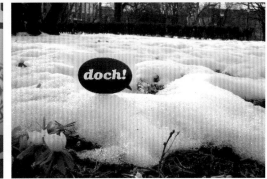

Katja Burmester II doch! I Germany

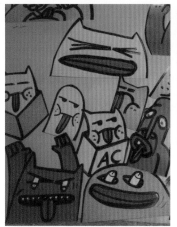
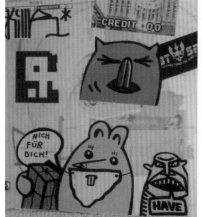
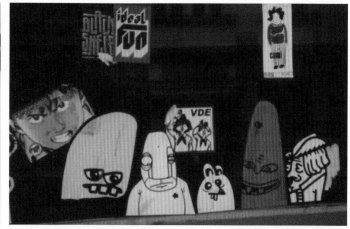
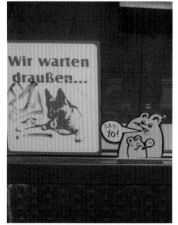

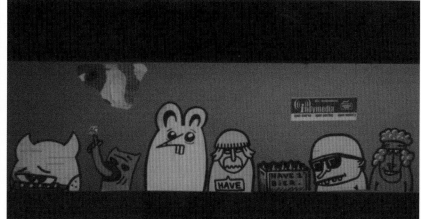

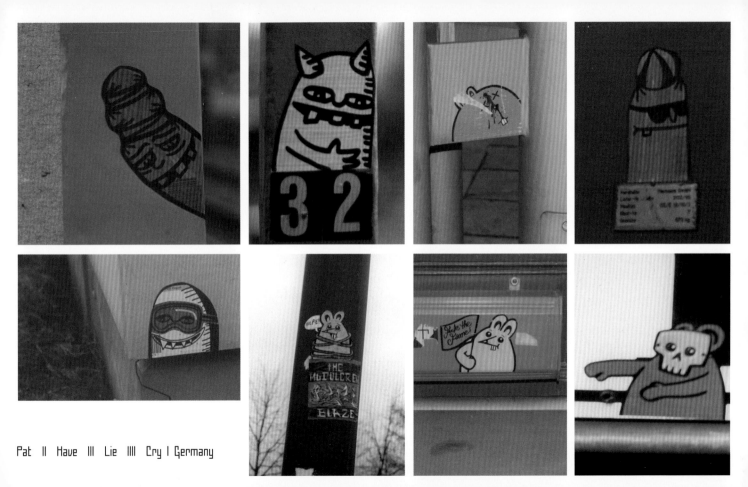

Pat ‖ Have ‖‖ Lie ‖‖‖ Cry ‖ Germany

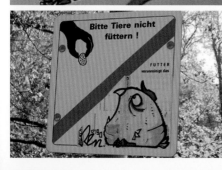

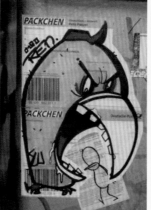

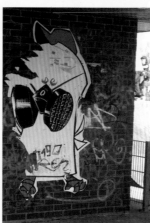

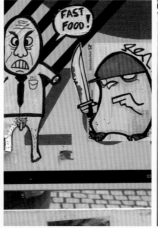

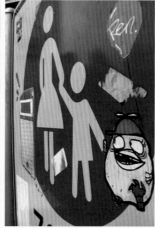

0190 Ren | Germany

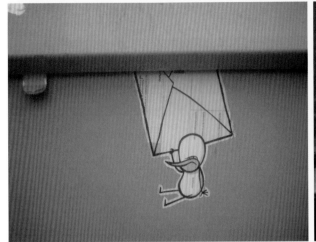
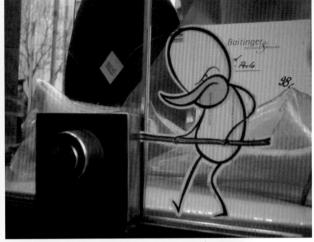
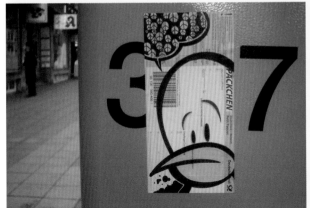
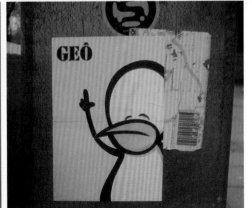

Geo | Germany

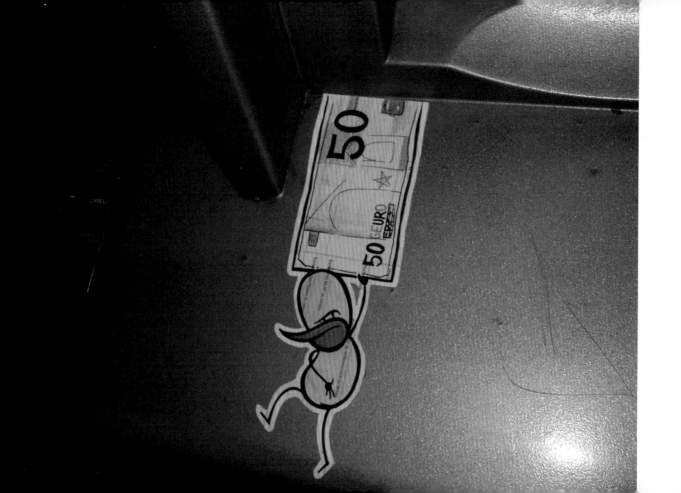

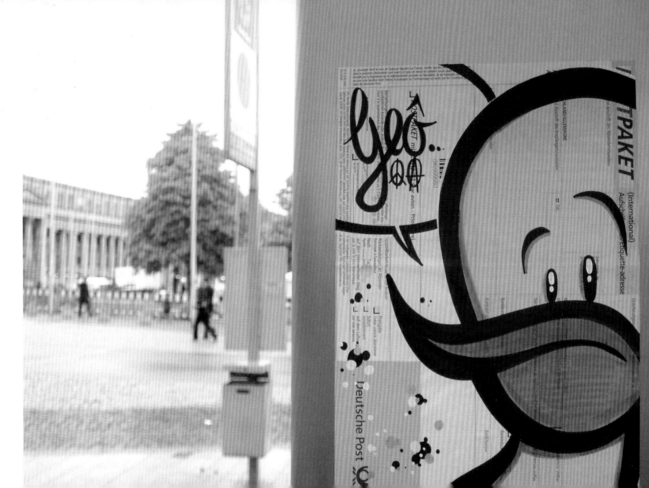

Geo | Germany

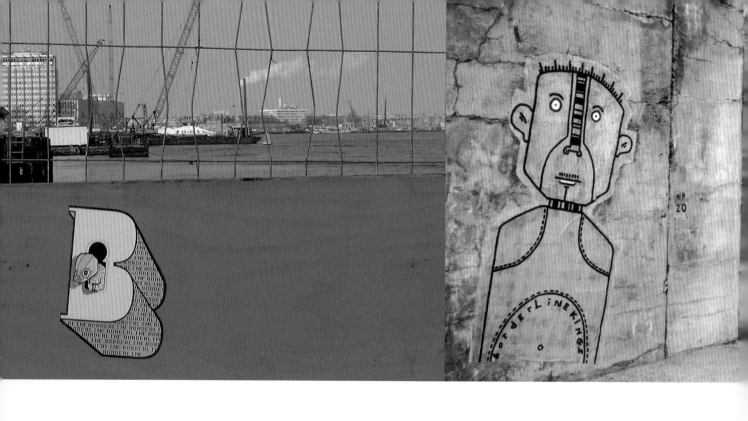

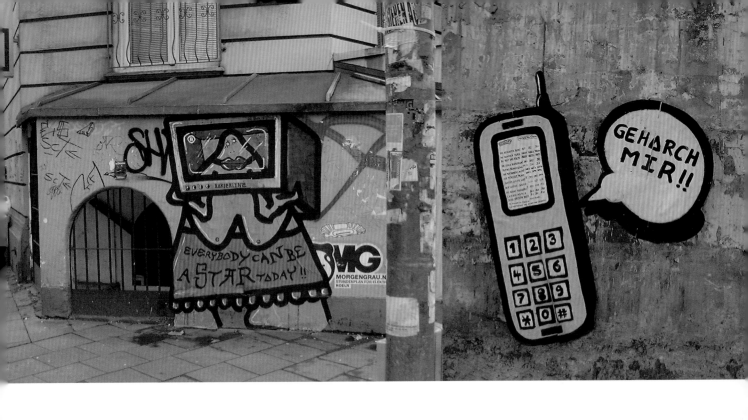

Captain Borderline | Germany

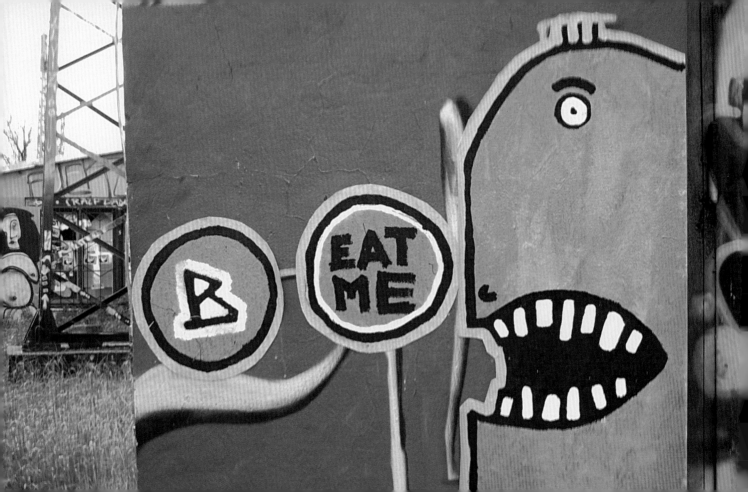

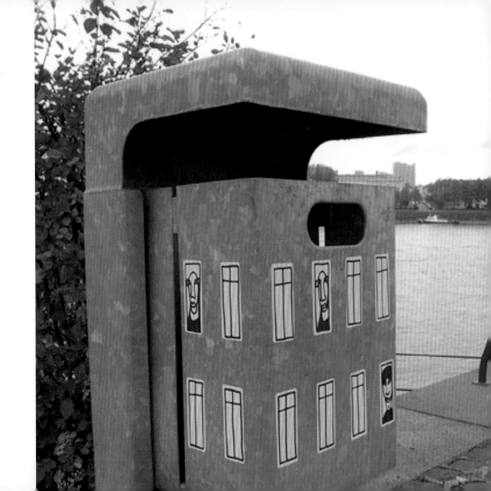

‹ Captain Borderline ‖ r-Quadrat | Germany

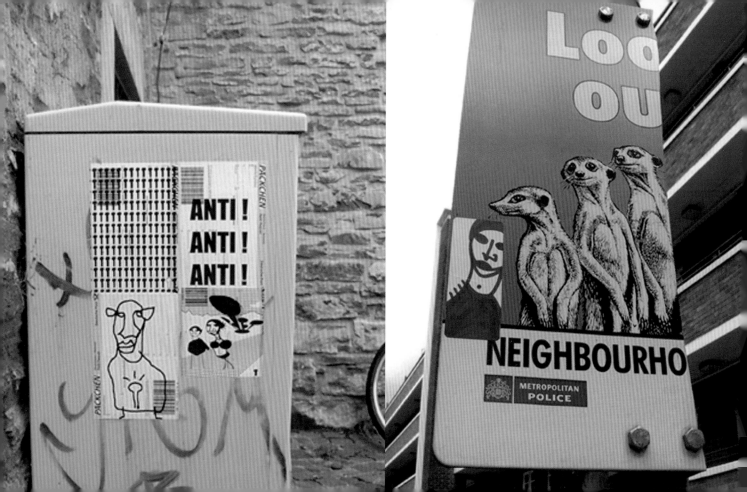

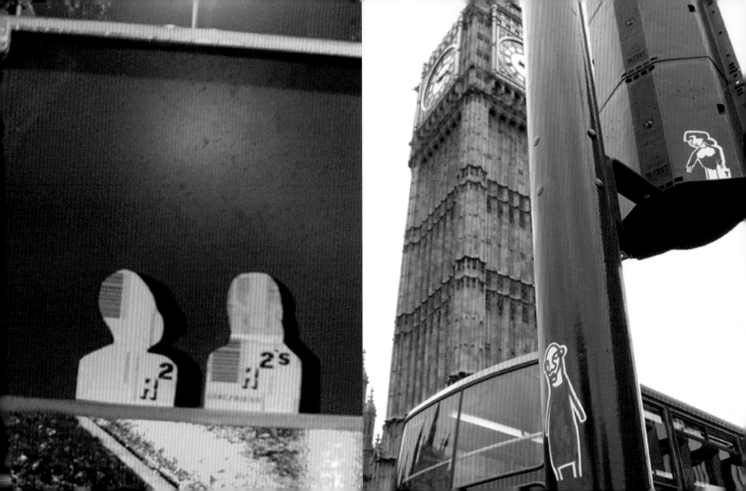

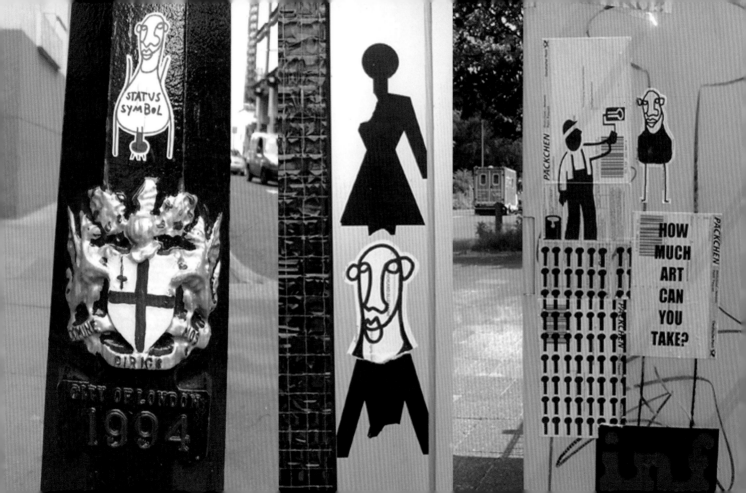

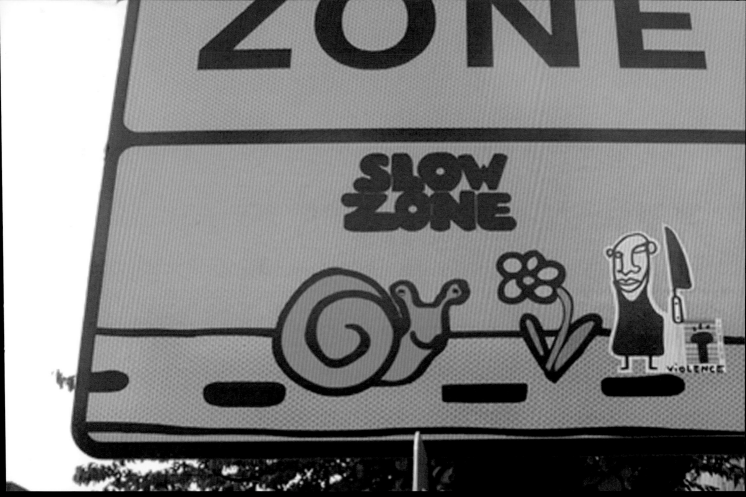

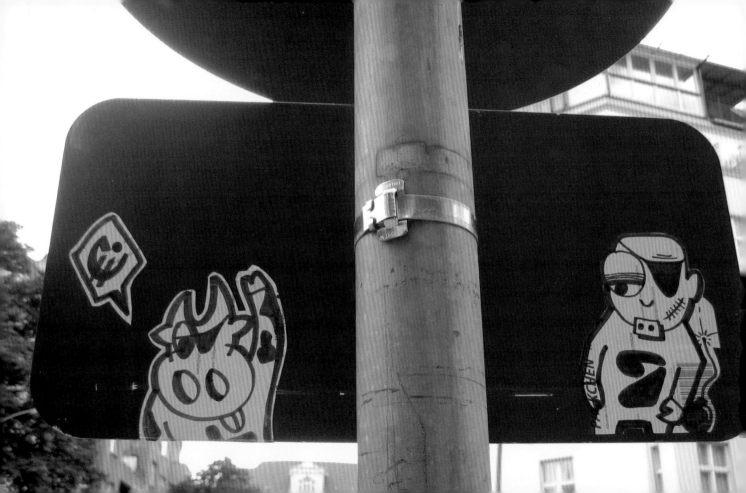

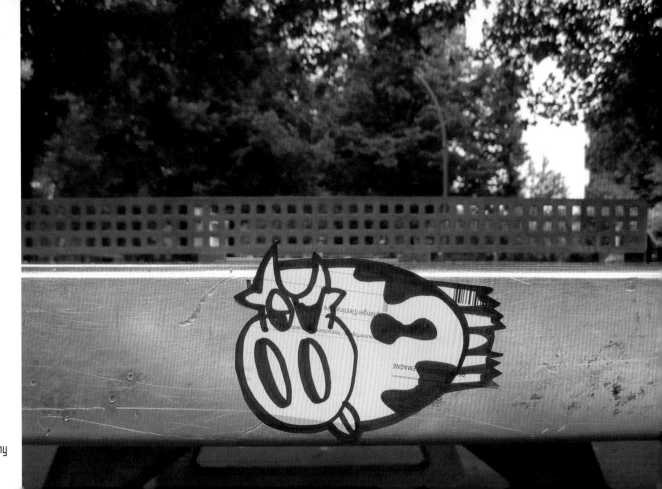

Dek 37 | Germany

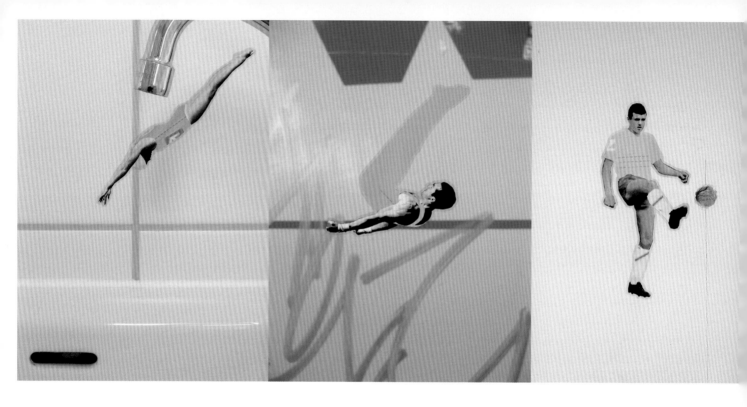

 '84

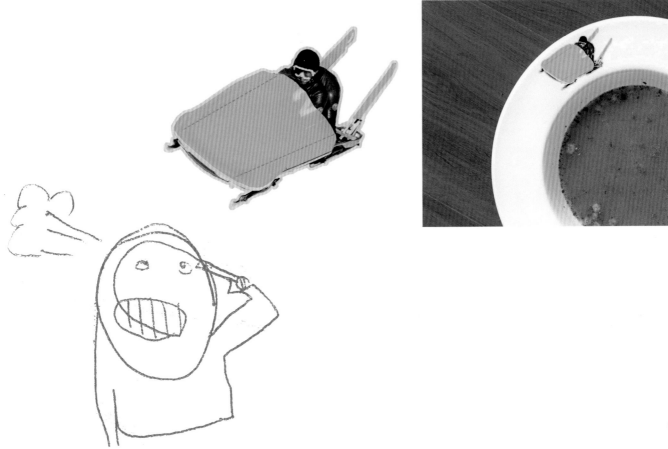

BABY KLAPPE

Bernd Fischer || Max Kuwertz | Germany

Karlotte | Germany

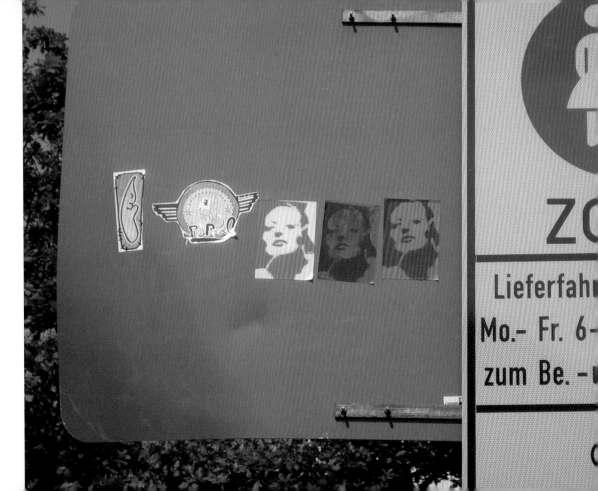

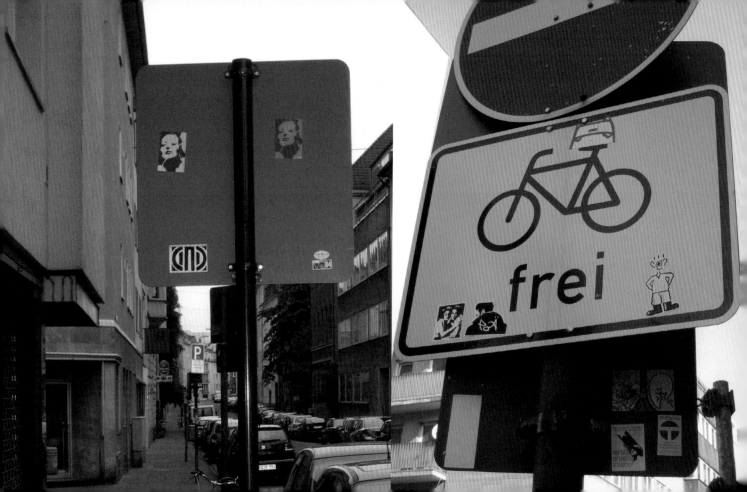

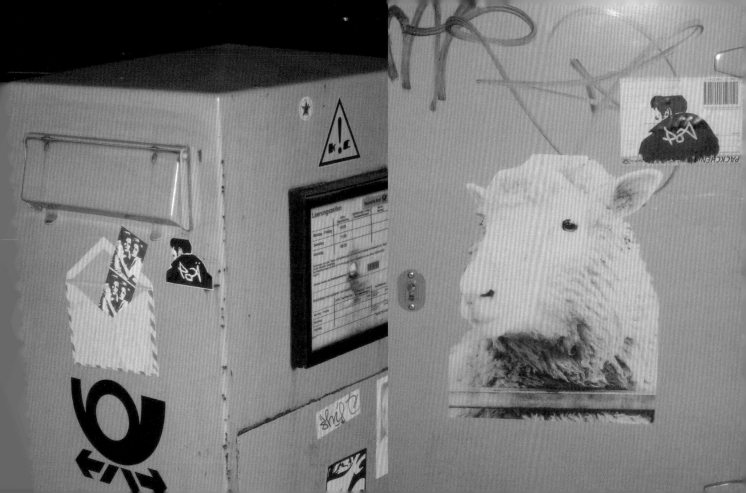

JESUS

YOU

I ❤ YOU 2

Oliver Rednitz | Germany

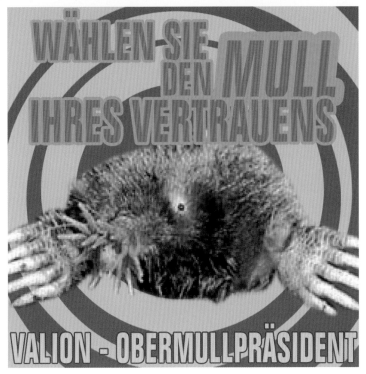

WÄHLEN SIE DEN MULL IHRES VERTRAUENS

VALION - OBERMULLPRÄSIDENT

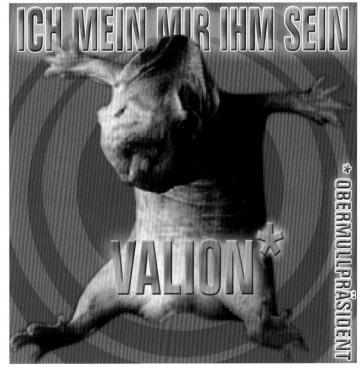

ICH MEIN MIR IHM SEIN

VALION*

* OBERMULLPRÄSIDENT

Valion | Germany

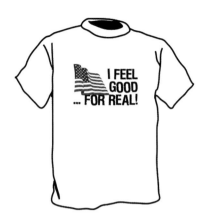

I FEEL
GOOD
... FOR REAL!

You're
THE MAN BEHIND
THE MAN
BEHIND THE GUN
www.recycle-your-reality.org

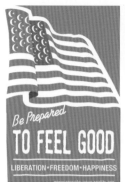

Be Prepared
TO FEEL GOOD
LIBERATION • FREEDOM • HAPPINESS
www.recycle-your-reality.org

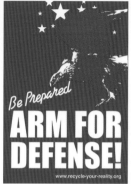

Be Prepared
ARM FOR
DEFENSE!
www.recycle-your-reality.org

today's
LIBERATION
CAMPAIGN
Active for freedom!

today's
LIBERATION CAMPAIGN
Active for freedom!
www.recycle-your-reality.org

today's
LIBERATION CAMPAIGN
Active for freedom!

PLEASE, LIBERATE ME TOO!

Bald wird für diese jungen Männer ein lang gehegter Wunsch in Erfüllung gehen. Aus dem politischen Umerziehungslager hinter ihnen wird nun eine neue Schule, in der Demokratie nach amerikanischem Vorbild unterrichtet wird.

Heute sind die ersten Schulbücher angekommen. Da haben natürlich alle mit angepackt. Sehen Sie die Freude in den Gesichtern der Buben. Nicht mehr lange, und sie werden so glücklich leben wie wir!

Doch viele Menschen auf unserer Erde leben noch in Tyrannenstaaten und werden täglich geknechtet! Die Zeit für eine freie und demokratische Welt ist gekommen. Strategische Entscheidungen für die Freiheit der Völker müssen getroffen werden.

Lassen wir uns nicht durch einen verblendeten Antiamerikanismus vom richtigen Weg abbringen.

Bitte unterstützen Sie unser Engagement und besuchen Sie noch heute unsere Internetseite für weitere Informationen.

www.recycle-your-reality.org

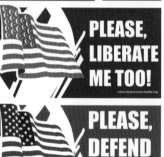

PLEASE,
LIBERATE
ME TOO!
www.recycle-your-reality.org

PLEASE,
DEFEND
ME TOO!
www.recycle-your-reality.org

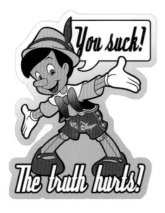

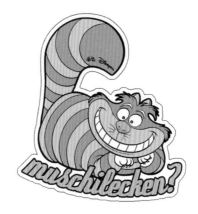

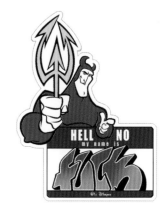

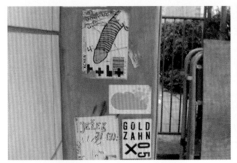

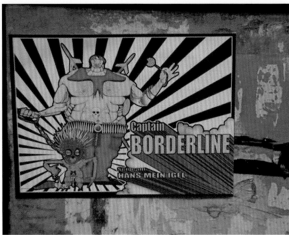

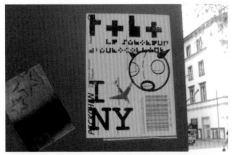

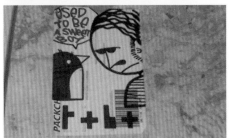

r+b+ ‖ Ron Voigt ‖‖ Fee ‖ Germany

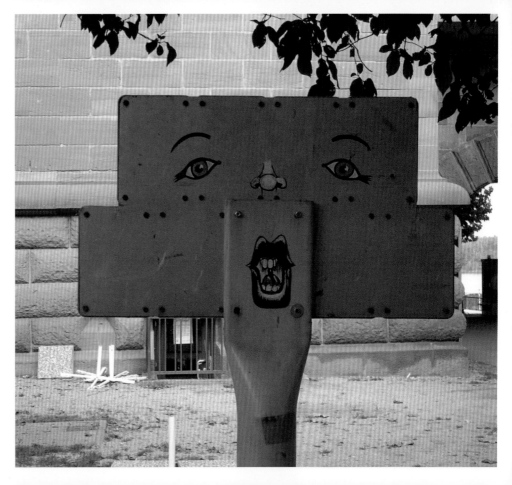

typefight || Zonenkinder | Germany

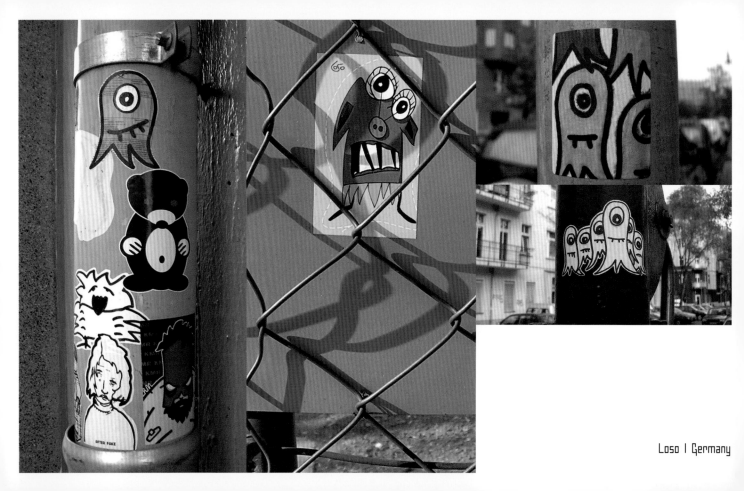

Loso | Germany

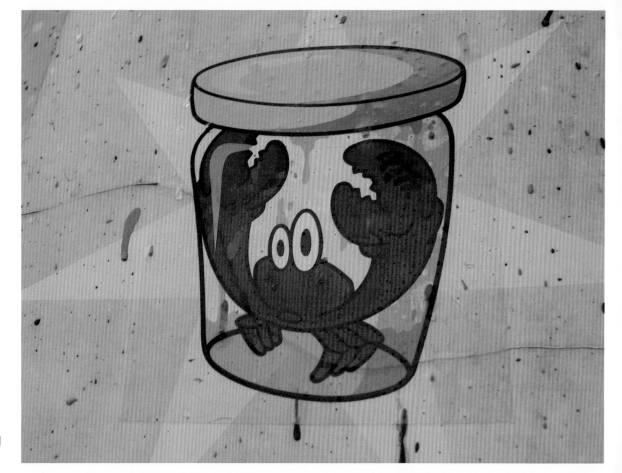

Maxi Moertl | Germany

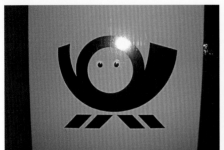
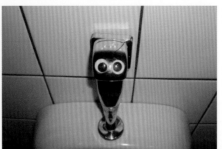

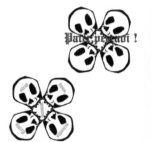

Terrordesign.com ‖ designadelt ‖| Birgit Jansen ‖‖ SoPejoe | Germany

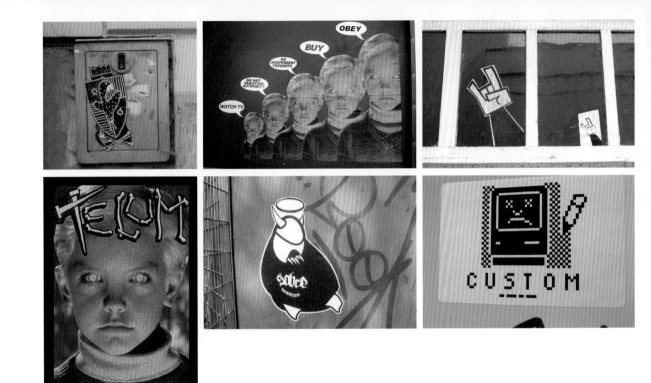

Daniel Wunder | Germany

www.radioskateboards.com

… ups!

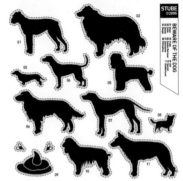

WANT A
FAMOUS
FACE?

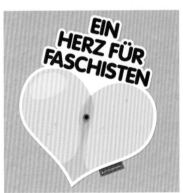

EIN
HERZ FÜR
FASCHISTEN

Radio || skurrilanthills ||| the cozy place |||| [...] ||||| Littlebowski | Germany

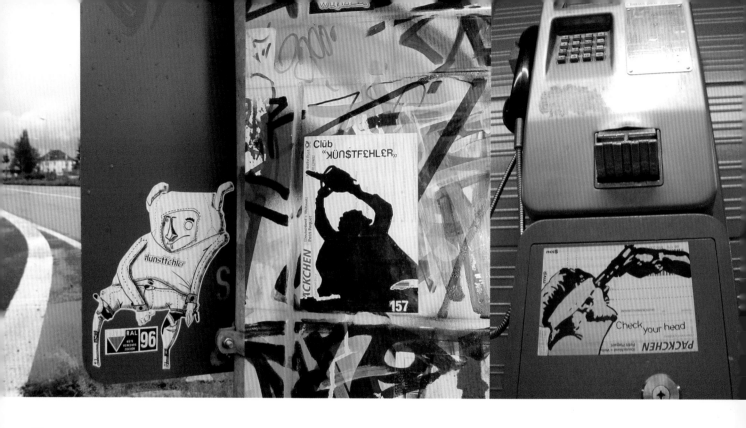

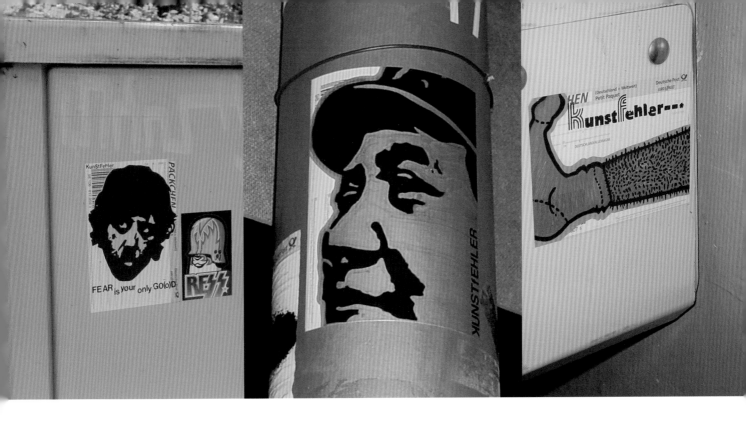

KunstFehler | Germany

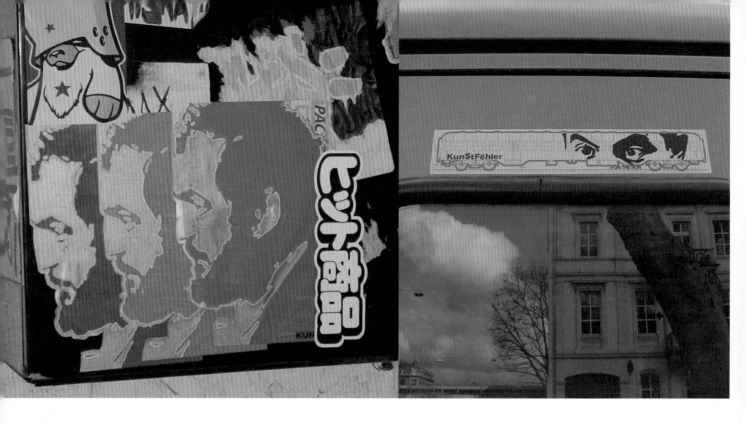

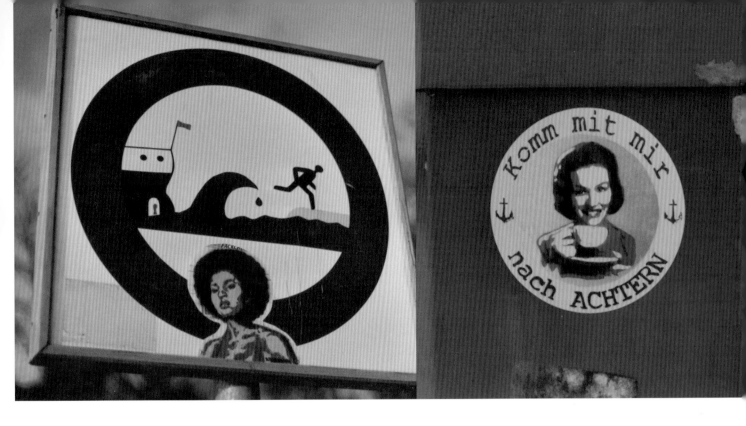

achtern | Germany

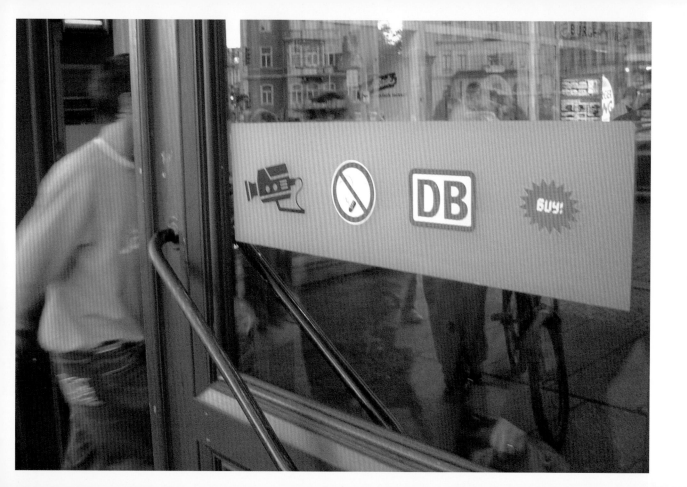

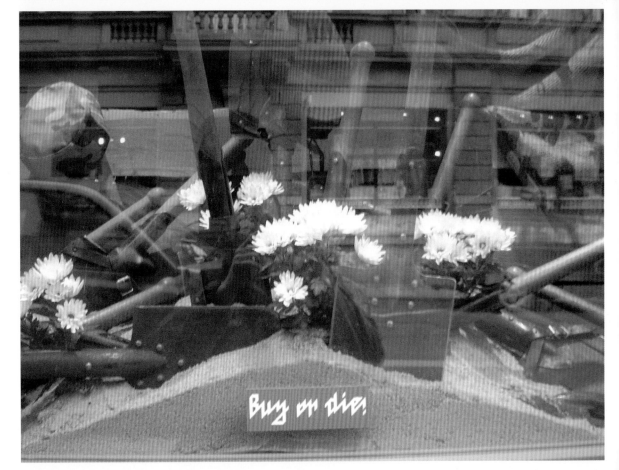

Gruppe Ideal | Germany

next pages: Gruppe Ideal | Germany

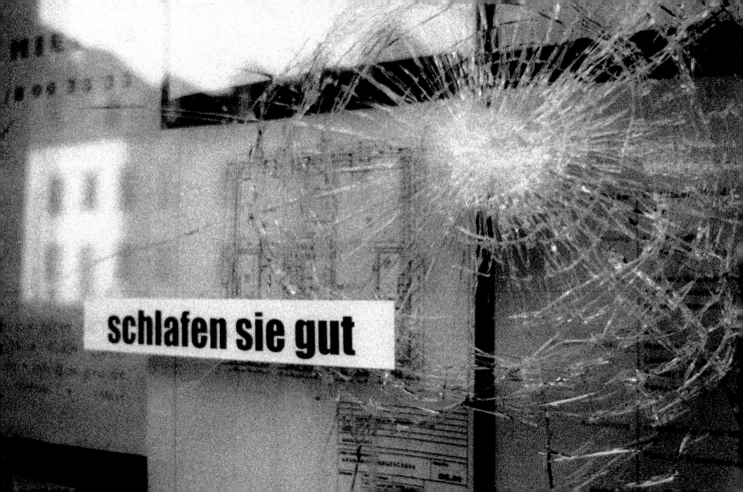

uns gefällt alles

Aus Sicherheitsgründen
wird dieser Raum

videoüberwacht

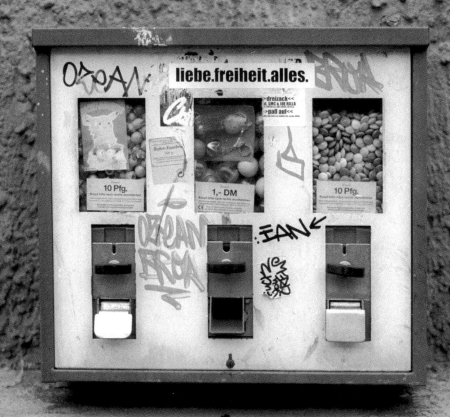

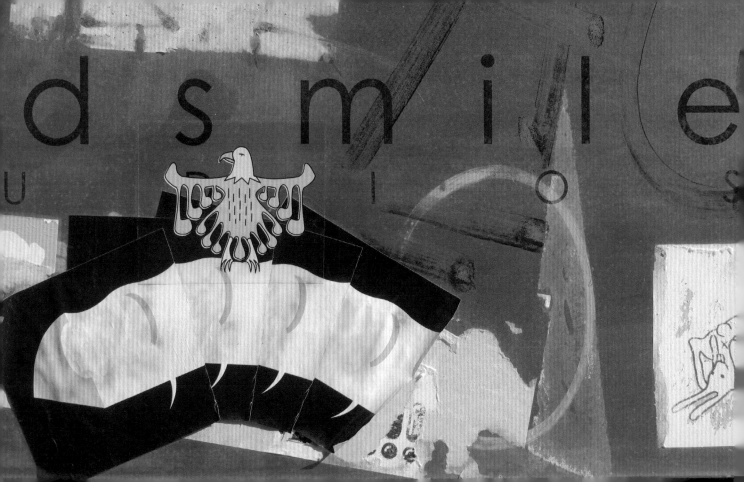

Gruppe Ideal | Germany

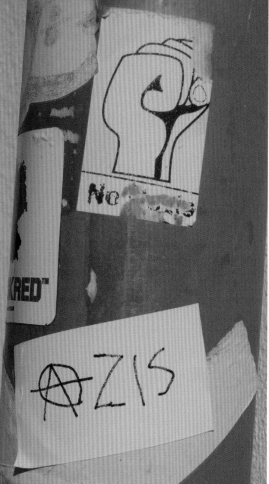
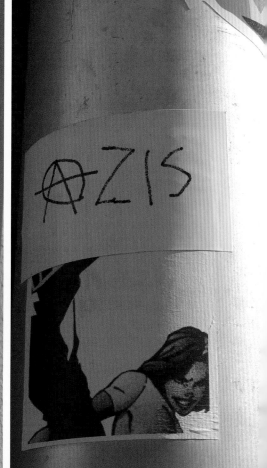

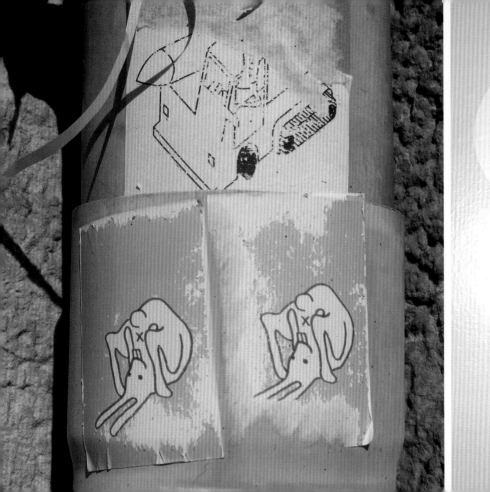

REFORGER '87

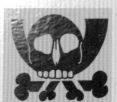

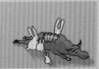

KRONE

DEFEKT

11880

tobaccoland
Automaten GmbH & Co. KG

Niederlassung Dresden
01069 Dresden
Tel.

Marlboro

PALL
MALL

PALL

Coca-Cola

41 1,50

DEFEKT

5 10 20 50 1 2

1	2	3
4	5	6
7	8	9
R	0	◻

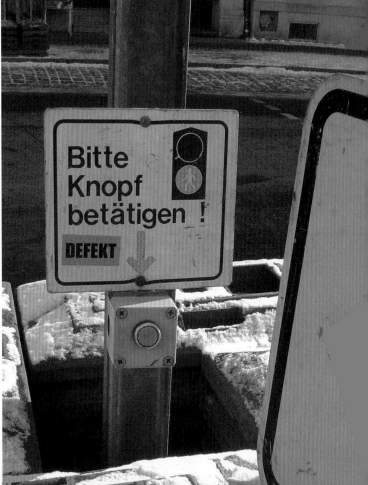

DEFEKT

Bitte
Knopf
betätigen !

DEFEKT

Gruppe Ideal | Germany

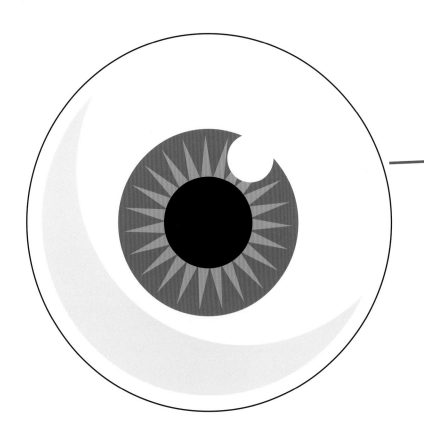

Schily bei ‚Big Brother' auf Sachsens Bahnhöfen

Film ab! Bundesinnenminister Otto Schily (SPD, 2. v. r.) lobte gestern Kameraaufzeichnungen auf Bahnhöfen (gr. F). „Kameras können wertvolle Arbeit bei der Abwehr von Gefahren leisten."

Schily besuchte eine 3-S-Zentrale (Service, Sicherheit und Sauberkeit) im Bahnhof Dresden-Neustadt, wo Bilder aus knapp 90 Kameras zusammenlaufen (kl. F). Anlass für die permanente Videoaufzeichnung war auch die Kofferbombe vom Dresdner Hauptbahnhof. Bei fehlendem Bedarf sollen die Aufzeichnungen nach 48 Stunden überschrieben werden. Die Deutsche Bahn hat rund 180 000 Euro in die permanente Videoaufzeichnung in Sachsen investiert.

Fotos: AP/
Matthias Rietschel

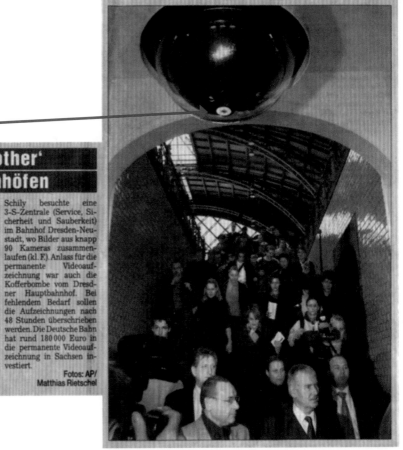

Mit der D-Mark an die Arbeit

Zurück zur D-Mark für eine zielgerechte Wachstumspolitik

In Deutschland muß die Wirtschaft wieder wachsen!

Helga Zepp-LaRouche
Kanzlerkandidatin der BüSo

Wählen Sie am 18. September die **BüSo**
Bürgerrechtsbewegung Solidarität

www.bueso.de

Erststimme Ströbele

BÜNDNIS 90 / DIE GRÜNEN

ERSTSTIMME NICHT VERSCHENKEN

MAFFAY
HALLENTOUR 2005

So., 27.11. BERLIN
Max-Schmeling-Halle
Beginn: 20 Uhr

SunTechnics

Erststimme: WERNER SCHULZ
BÜNDNIS 90 / DIE GRÜNEN

Oskar Lafontaine: Nichts ist mächtiger als eine Idee, deren Zeit gekommen ist.*

DIE LINKE. PDS

Freitag, 16. September, 18.30 Uhr
Augustusplatz

Sozial sein heißt: Arbeitsplätze schaffen

Informationsstände und Vorprogramm ab 16.00 Uhr

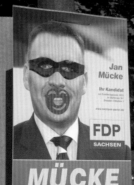

Alexander Achminow

CDU

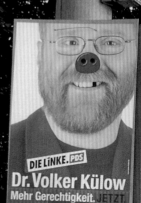

Jan Mücke

Ihr Kandidat

FDP SACHSEN

MÜCKE
NEUE KRAFT FÜR DEUTSCHLAND

DIE LINKE. PDS

Dr. Volker Külow
Mehr Gerechtigkeit. JETZT.

Ideal | Germany

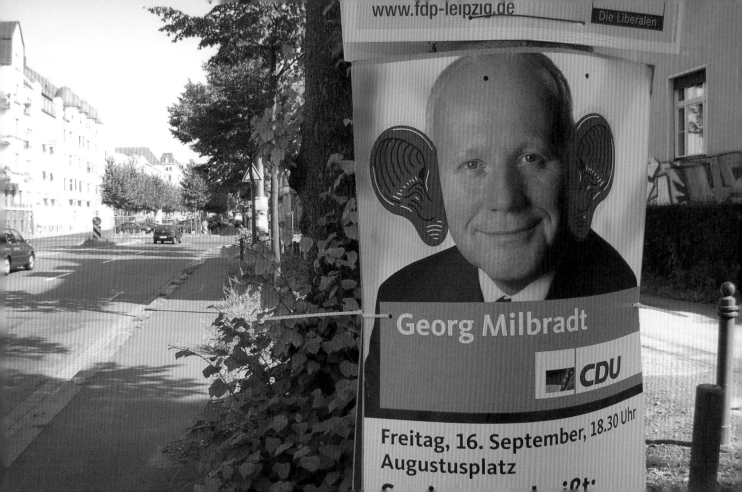

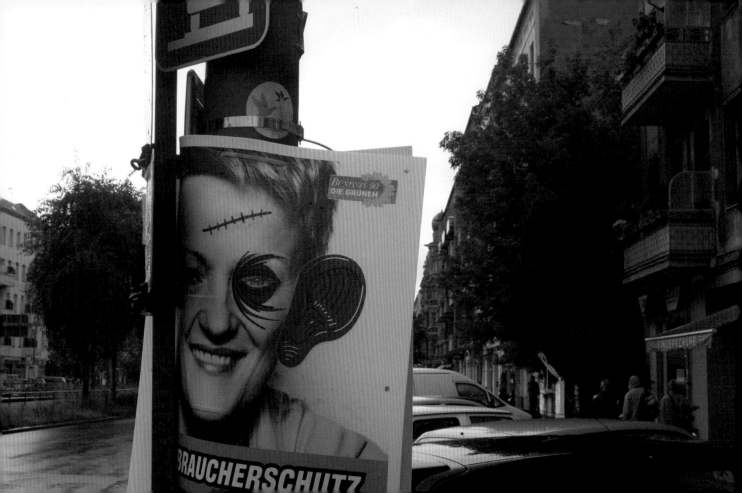

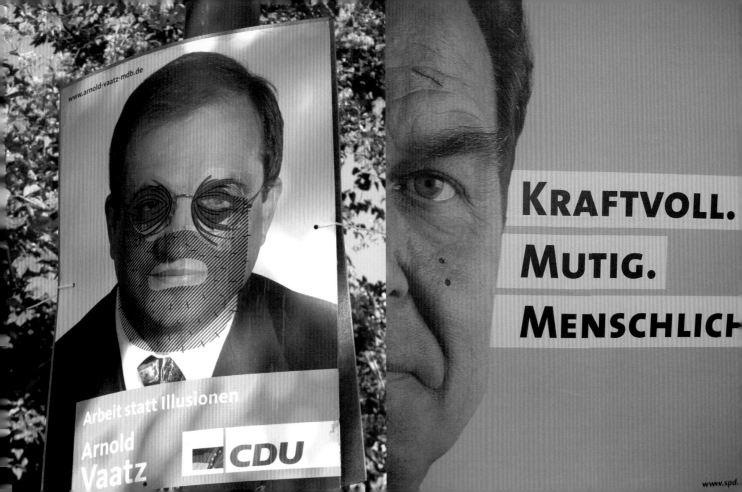

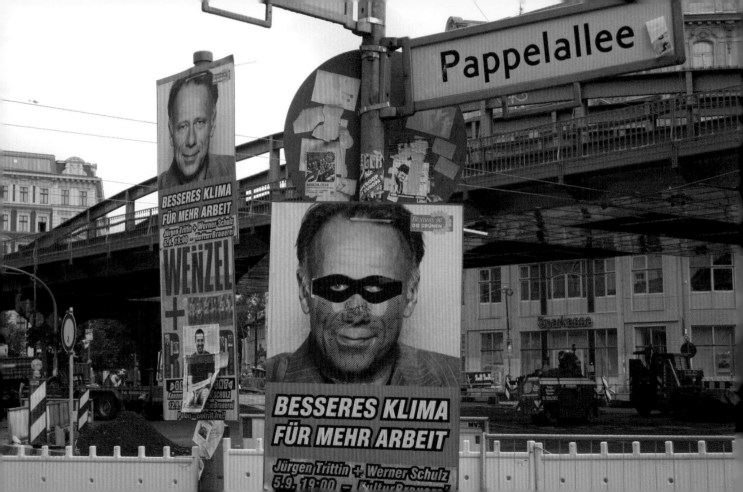

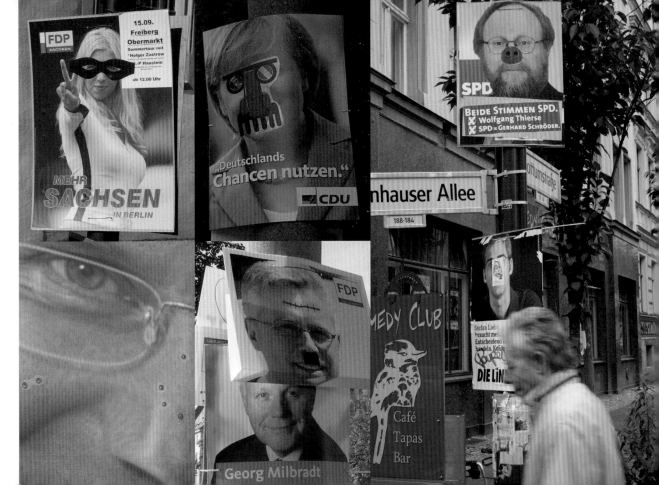

Ideal | Germany

I went to artschool and all I make now is this lousy sticker...

erosie 2004

THIS STICKER WILL SELF DESTRUCT

AS TIME GOES BY...

erosie 2004

Erosie | Germany

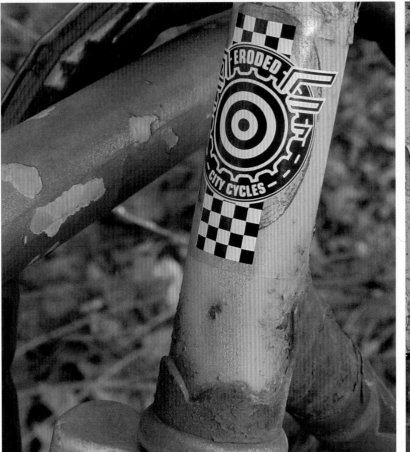

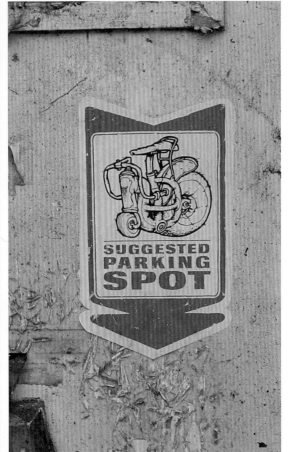

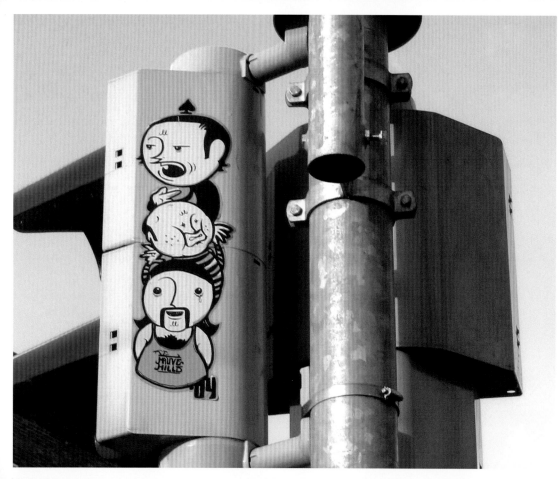
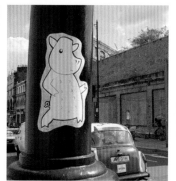
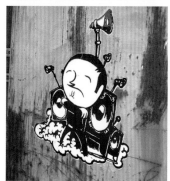

Mauve Balls | Netherlands

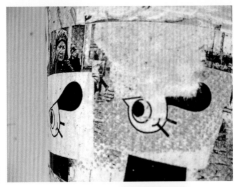
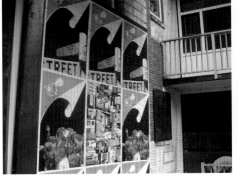
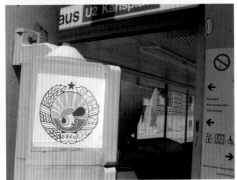
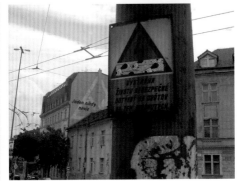

Oles | Netherlands

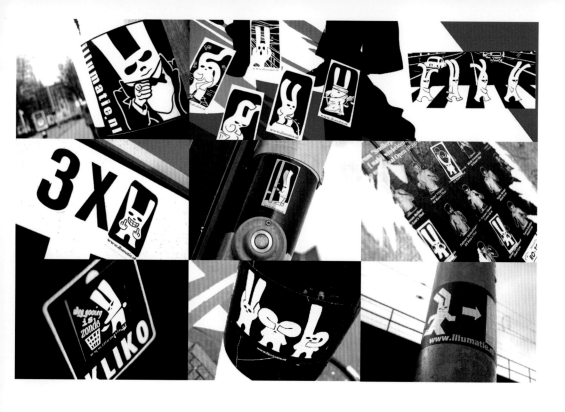

Matt Bay II Oles I Netherlands

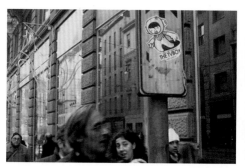 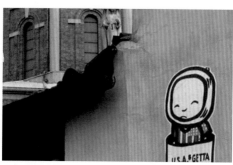 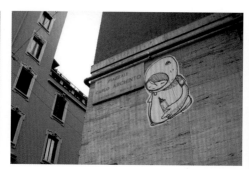

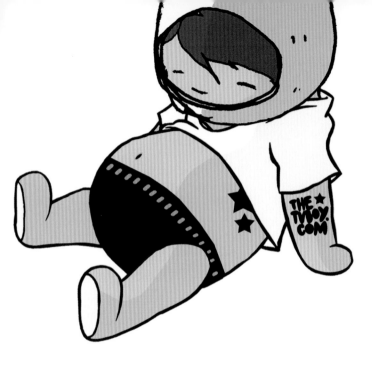

Tvboy | Italy

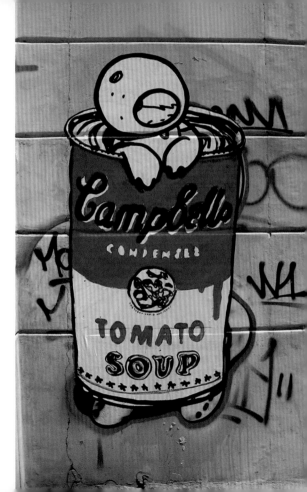

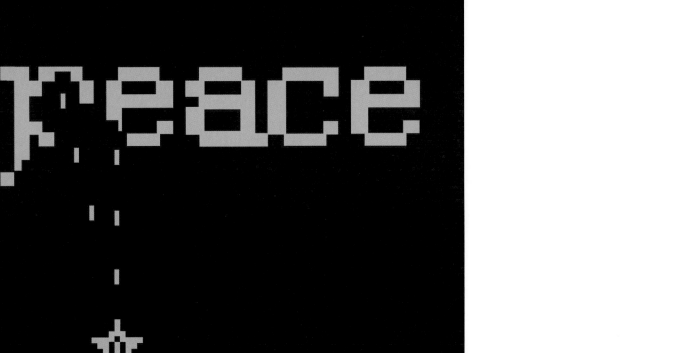

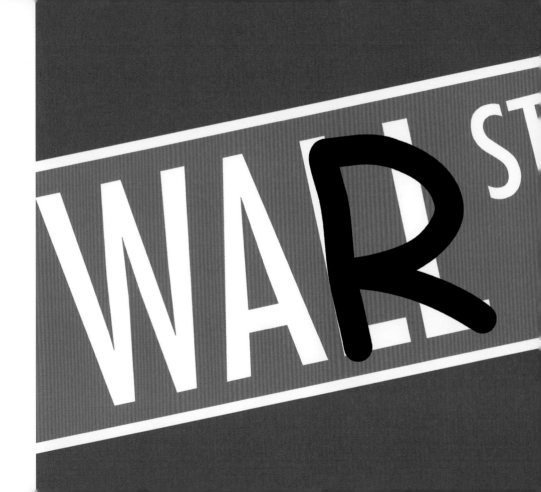

Luca Rapuano | Italy

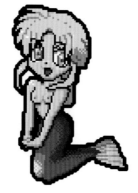

LOOKING FOR MY SON

Accion Mutante

CONTRO IL CATTIVO GUSTO.
CONTRO LA CREATIVITA' DI REGIME.

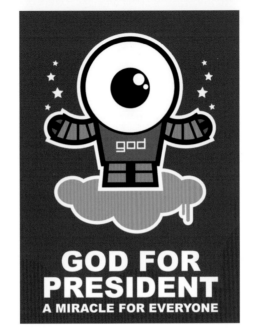

GOD FOR PRESIDENT

A MIRACLE FOR EVERYONE

dopeypuppy

I STILL LOVE YOU

ColonIrritabile || Diegobao | Italy

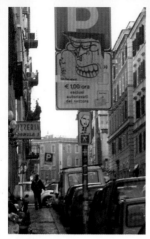
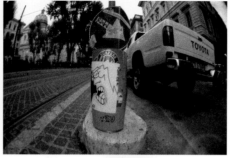
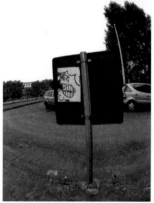

142

Angelo ll Mr.Unique lll Micro_b llll Kaneda l Italy

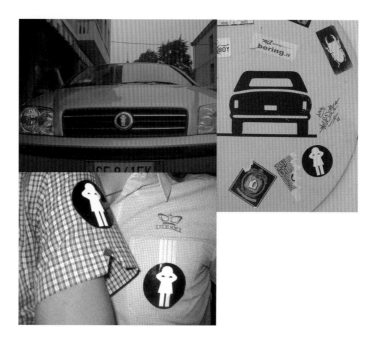

Elena Mirandola | Italy

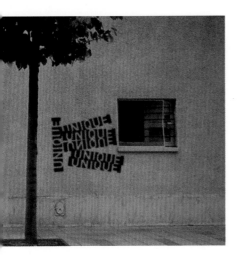

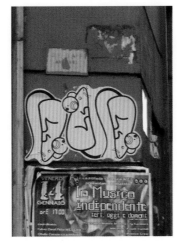

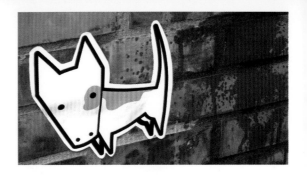

Fabrizio ‖ Solid 103 ‖‖ P Dog ‖‖‖ Sear ‖ Italy

 145

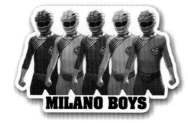

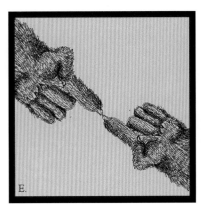
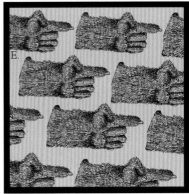

Ethel | Italy

before II IV

show your difference

Captain Anarky | Italy

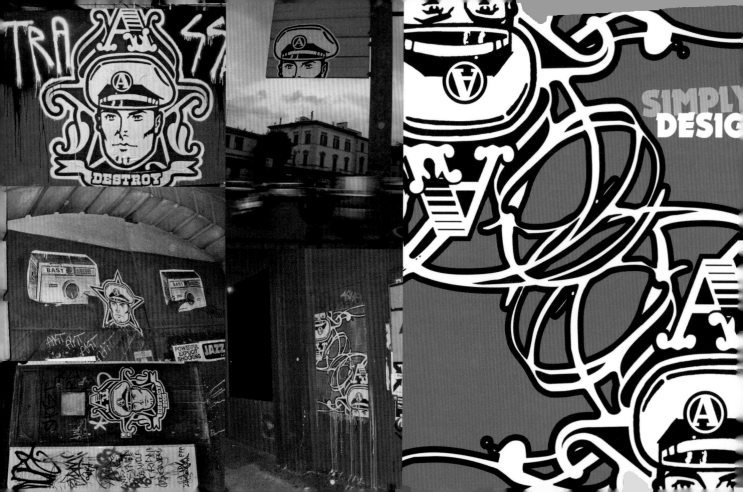

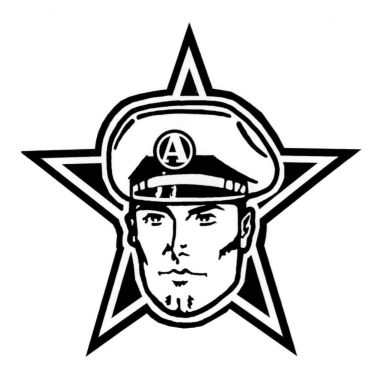

DESTROY
2005

Captain Anarky | Italy

OPEN YOUR EYES!

feed your head!

FREE YOUR MIND!

Andrea Simonato I Italy

only the naked truth!

let it surprise you!

warning, they could betray you!

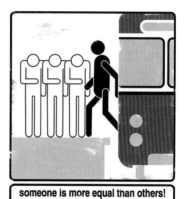

someone is more equal than others!

Andrea Simonato | Italy

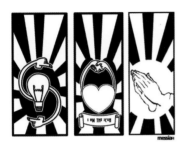 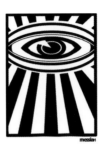 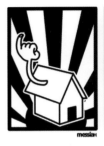 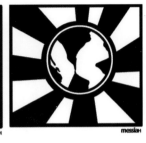

Patty II Messiah III YAUUkorpeßiliz I Italy

155

PREGNANT PIXEL

Jealous Guy

156

UNITED STATES OF AMERICA

Luca Rapuano | Italy

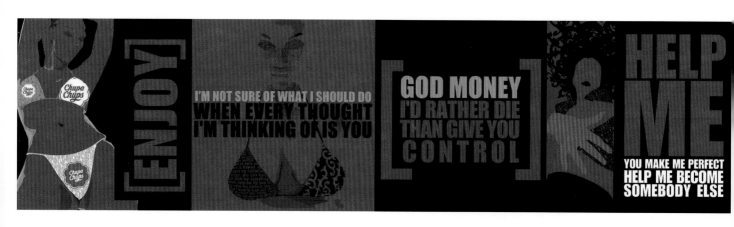

[ENJOY]

I'M NOT SURE OF WHAT I SHOULD DO
WHEN EVERY THOUGHT
I'M THINKING OF IS YOU

GOD MONEY
I'D RATHER DIE
THAN GIVE YOU
CONTROL

HELP
ME

YOU MAKE ME PERFECT
HELP ME BECOME
SOMEBODY ELSE

158

Giovanna Grauso | Italy

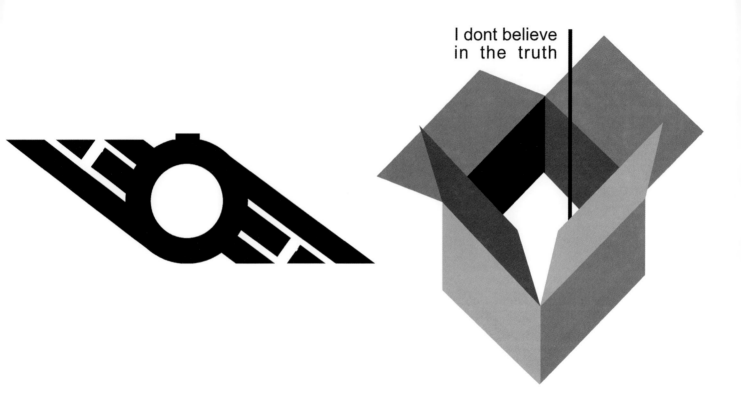

I dont believe
in the truth

bidbid | Italy

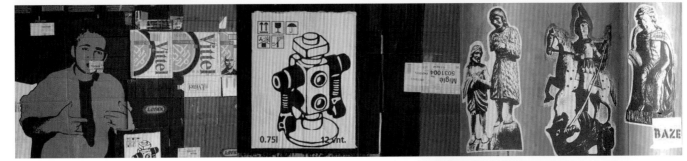

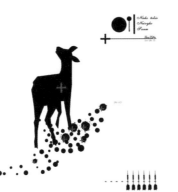

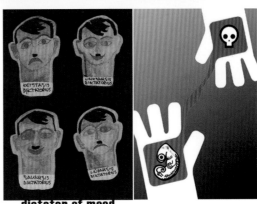

dictator of mood

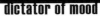

Arnas PAL | Lithuania

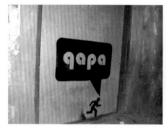
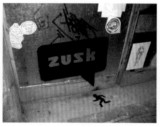

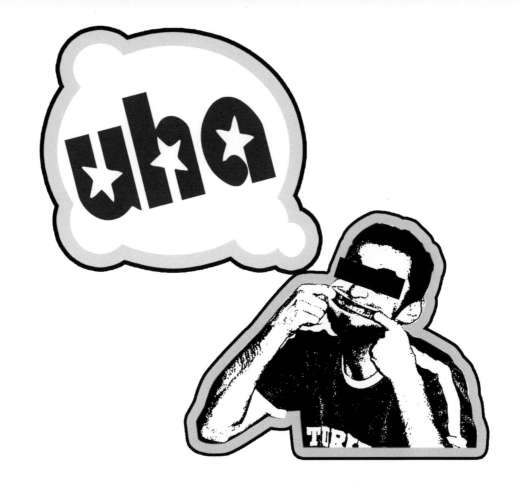

007Team || Lopez | Poland

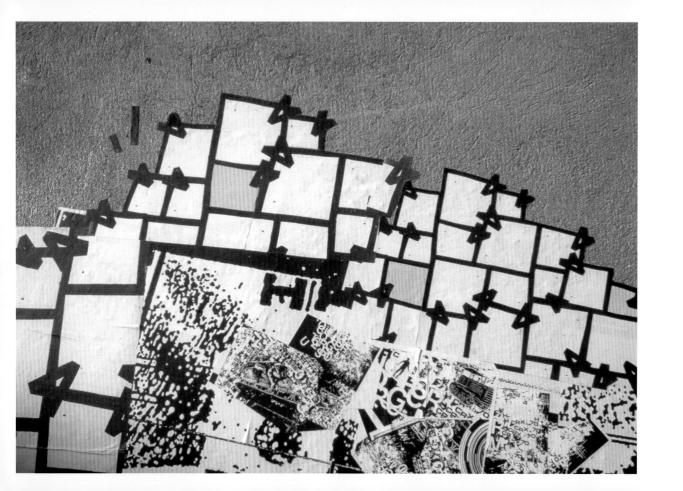

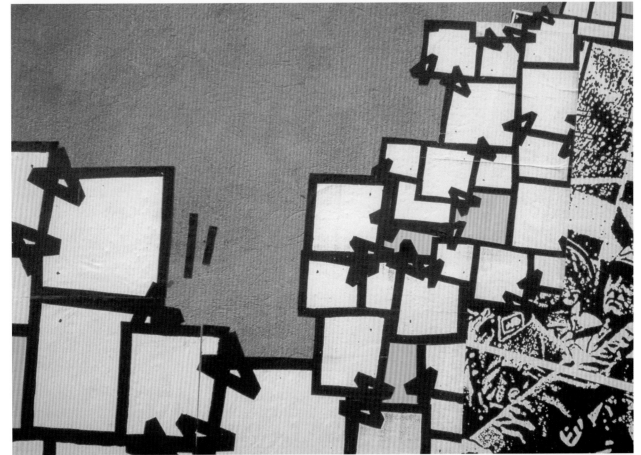

Zysk 83 I Poland

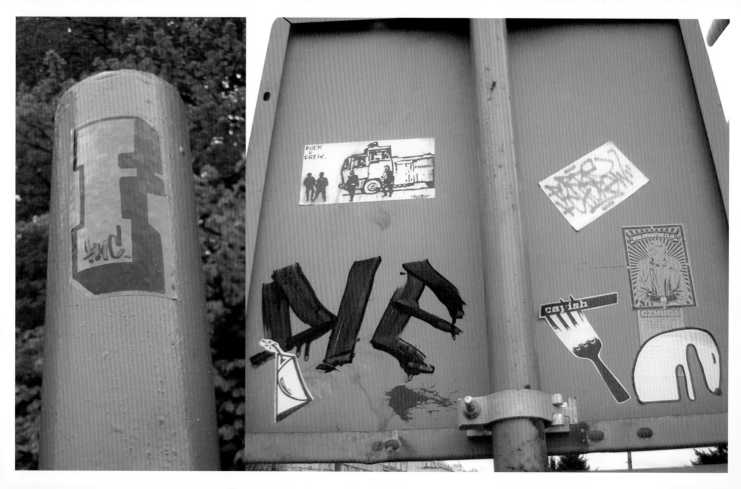

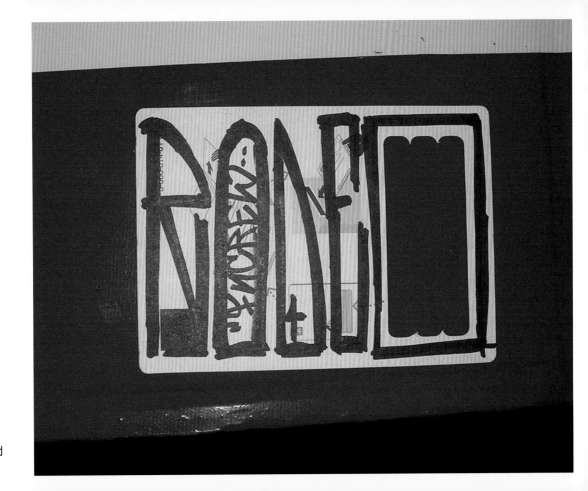

Rodeo Kid+Fuck Crew I Poland

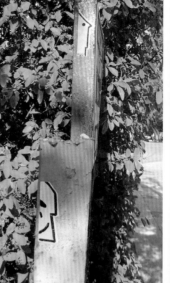
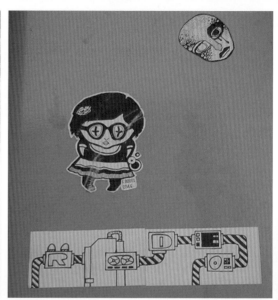

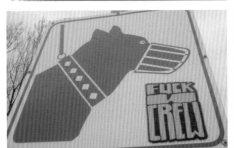

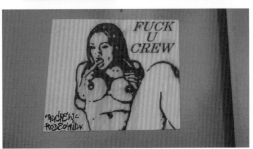

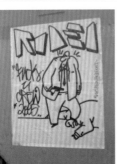

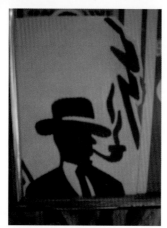

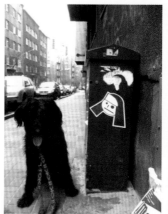
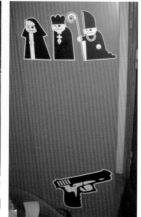
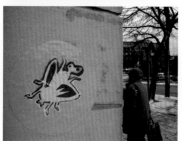
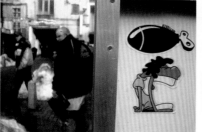
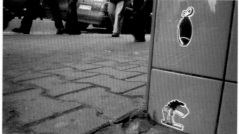

Rodeo Kid II Istot III NunzHuorz IIII Filip Mucha IIIII Swedzki I Poland

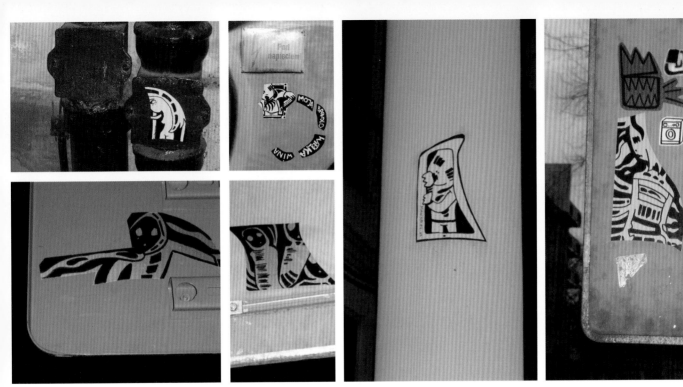

Magit | Poland

Monia | Portugal

★ LUSOMUNDO ★

O PARAISO DA BARAFUNDA

GARFIELD VP

SUPRE A

CRONICAS DE RIDDICK

O REI ARTUR O TERMINAL

CONNIE E CARLA I ROBOT

A VOLTA AO MUNDO EM 80 DIAS

Claun | Portugal

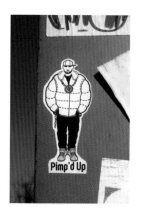

Ciubi ll Ioana lll Agnes E. l Romania

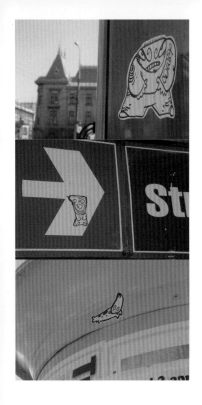

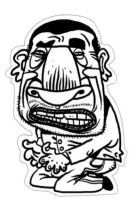

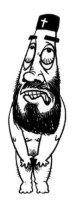

Ciubi | Romania

Irina S | Romania

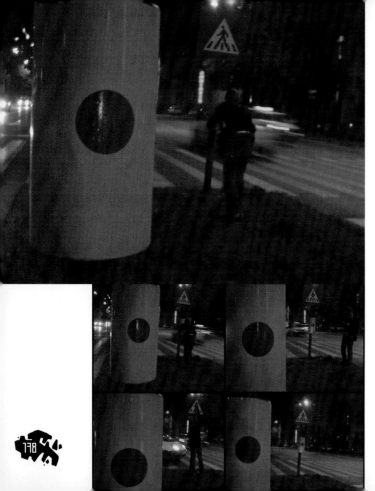

178

WE'RE AFTER YOU

TheOilersGang II Wanda Hutira I Romania

artist

curator

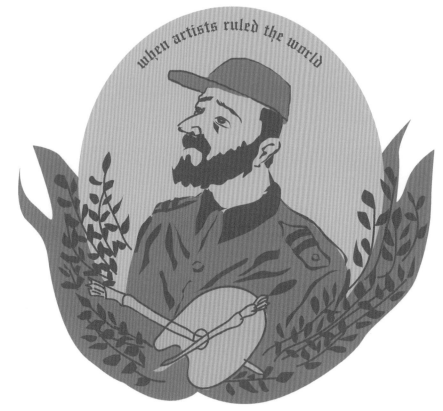

when artists ruled the world

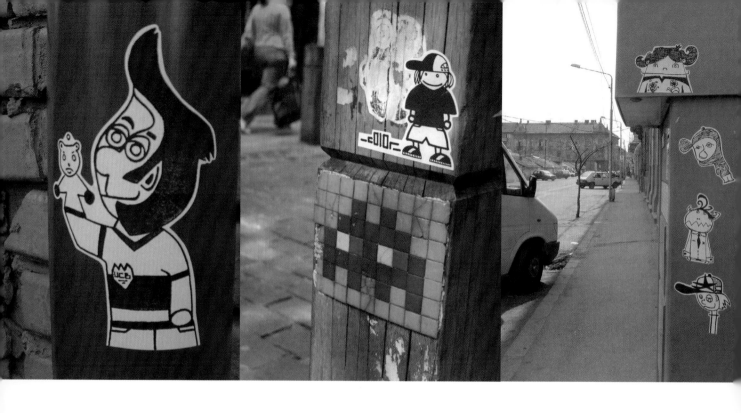

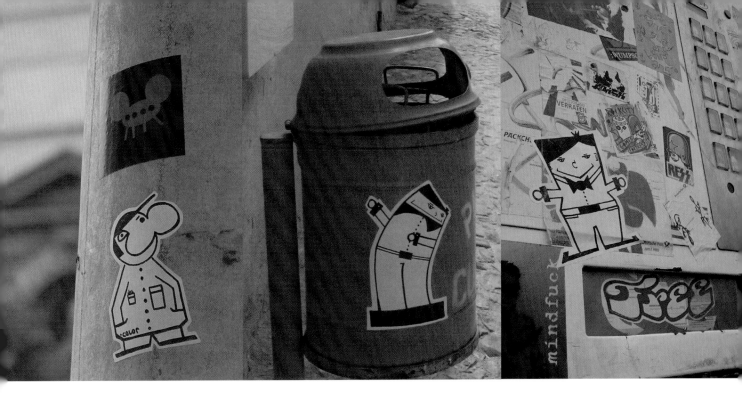

Color | Romania

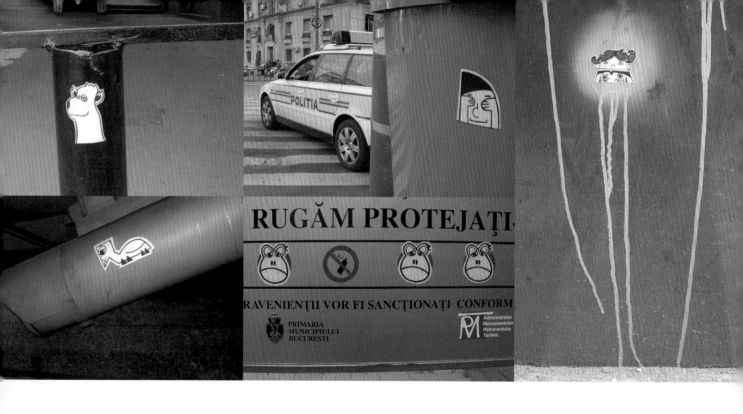

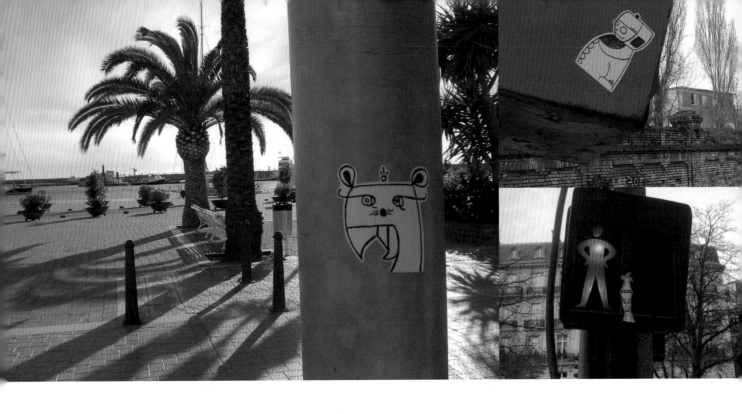

Color | Romania

186

ya | Russia

realsheep

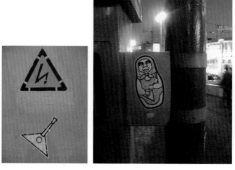

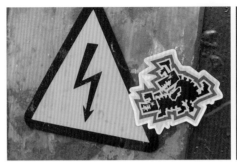
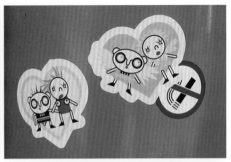
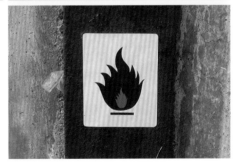

Ma_o | Russia

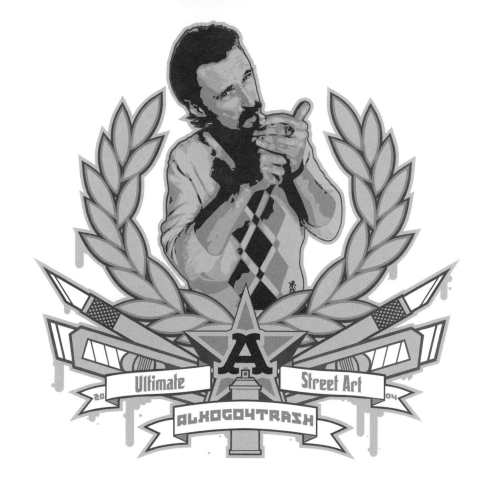

Ultimate Street Art

ALKOGO4TRASH

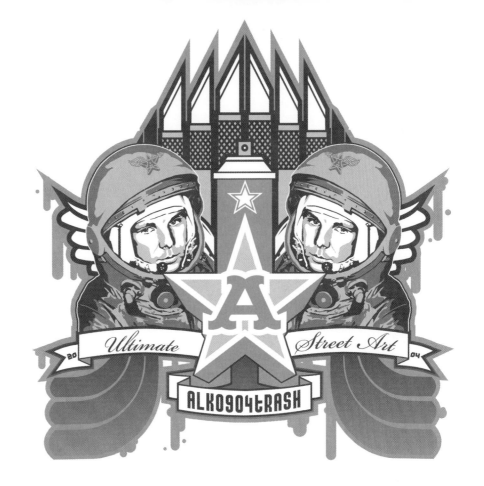

Ultimate Street Art

ALKO904tRASH

Alkostars | Russia

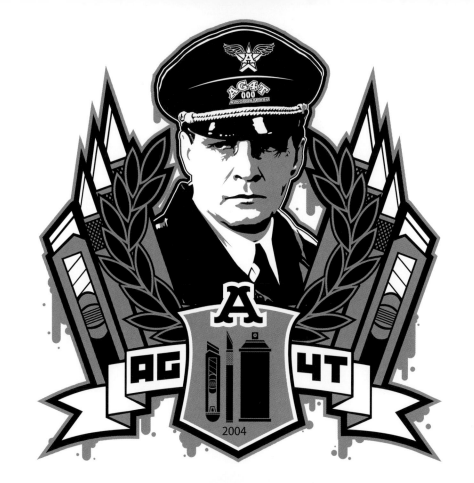

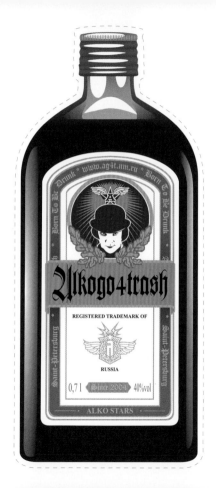

Alkostars | Russia

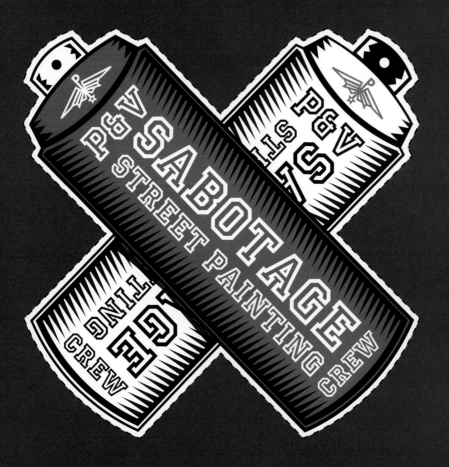

SABOTAGE STREET PAINTING CREW

P&V STILL

CREW

xb7x | Russia

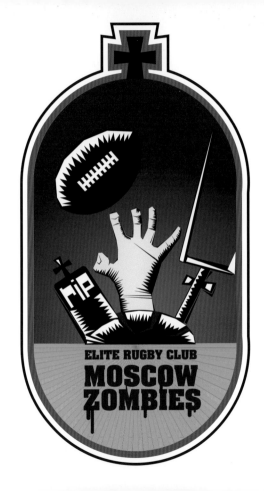

ELITE RUGBY CLUB
MOSCOW
ZOMBIES

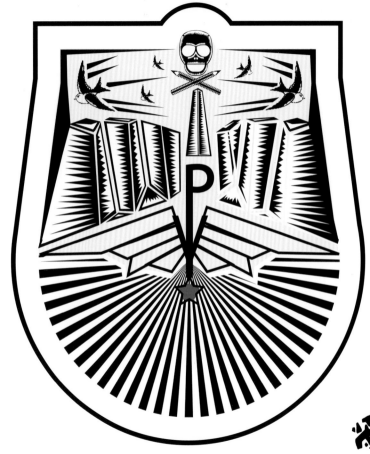

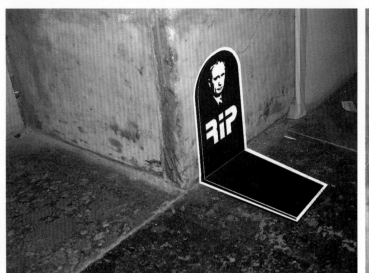

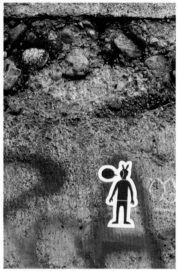

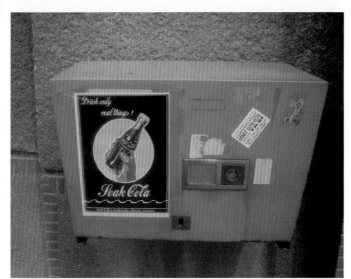

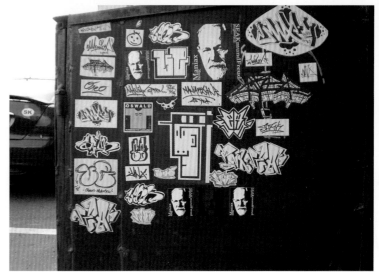

Seak n Oreo | Slovakia

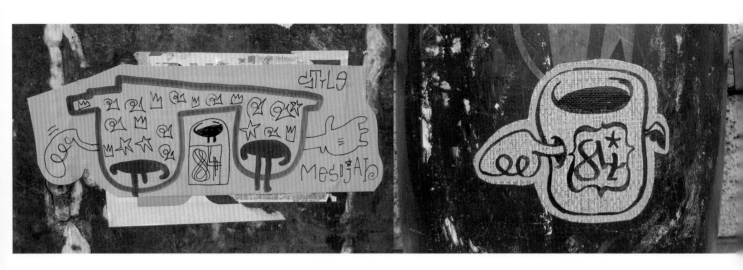

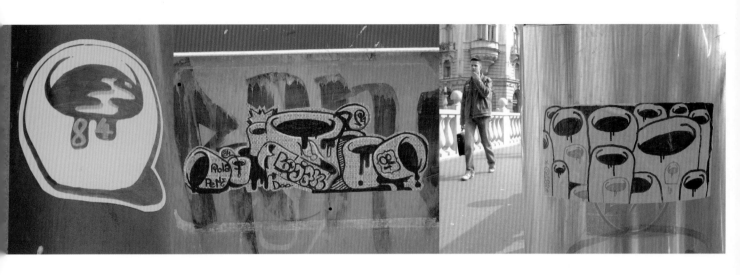

Rone84 | Slovenia

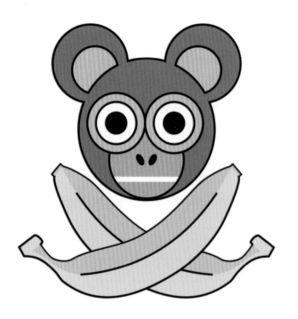
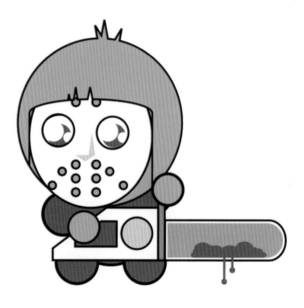

 200

Soni Makarovic | Slovenia

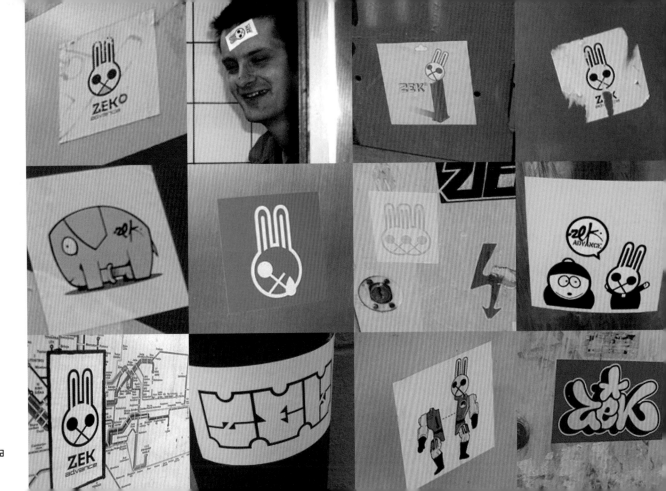

ZEK | Slovenia

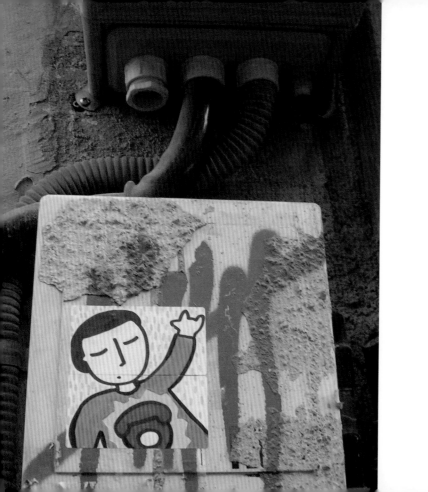

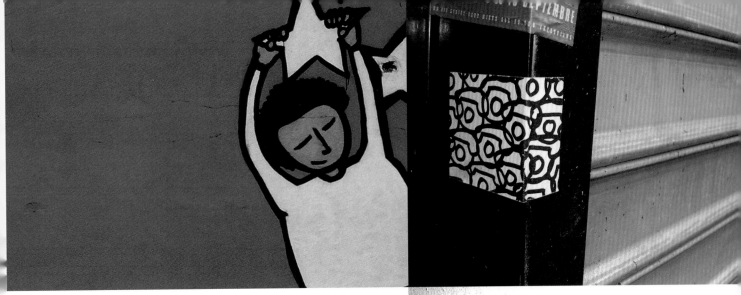

Aing | Spain

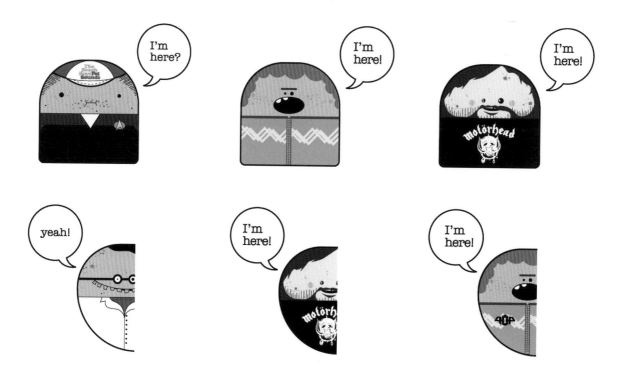

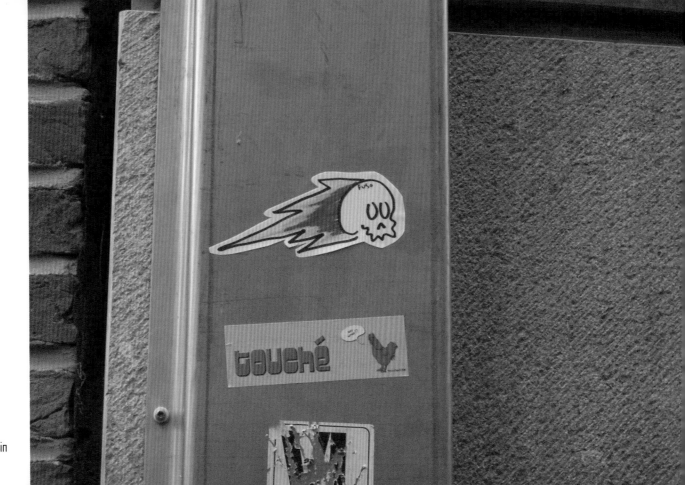

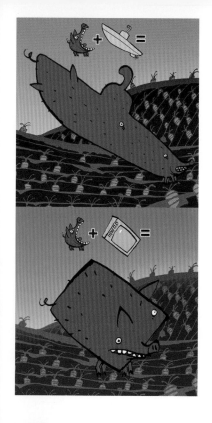

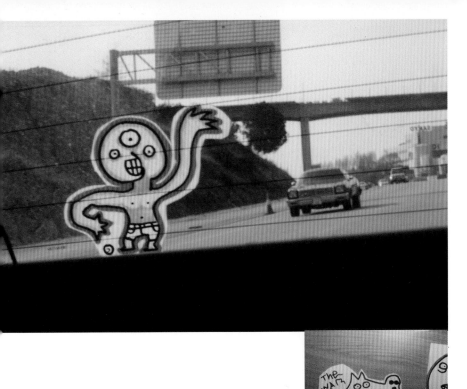

bie II FuLL I Spain

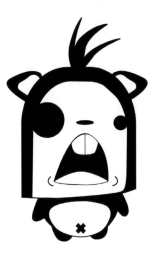

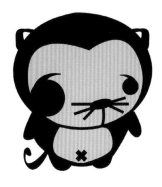

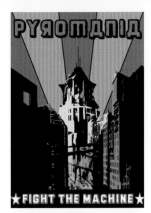

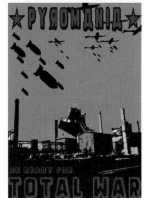

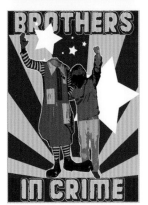

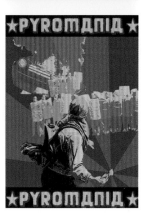

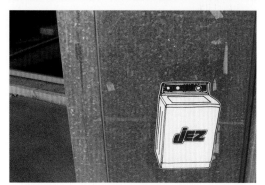
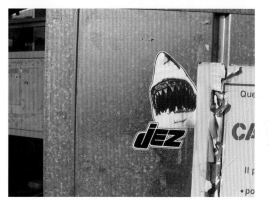
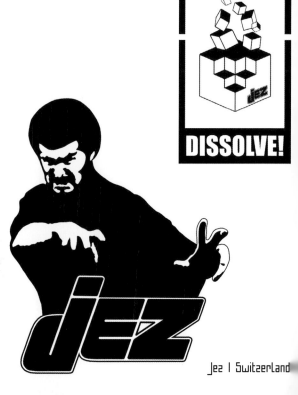

DISSOLVE!

Jez | Switzerland

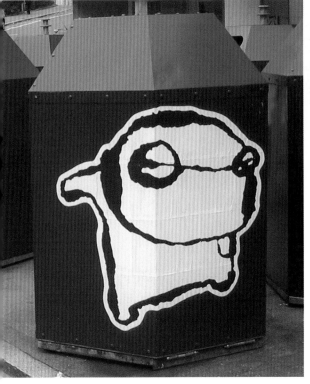
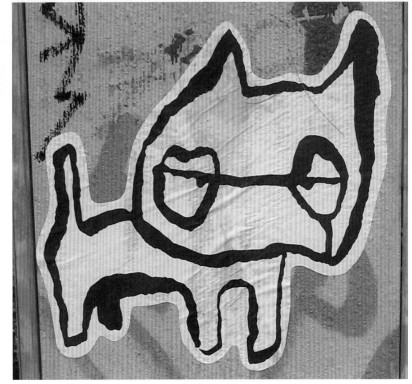

Wheesel | Switzerland

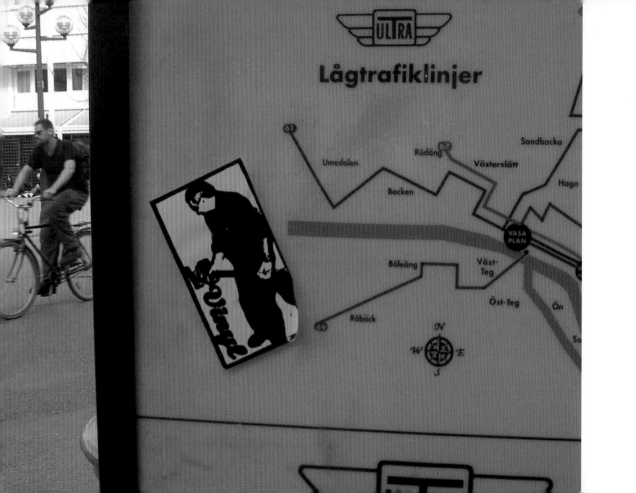

ULTRA

Lågtrafiklinjer

61

Umedalen

Rödäng 67

Sandbacka

Västerslätt

Backen

Haga

VASA
PLAN

Böleäng

Väst-
Teg

Öst-Teg

Ön

Röbäck

So

N
W E
S

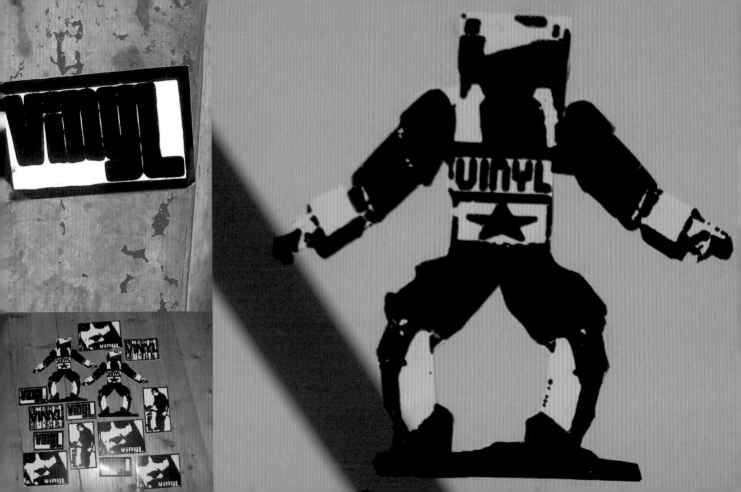

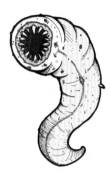

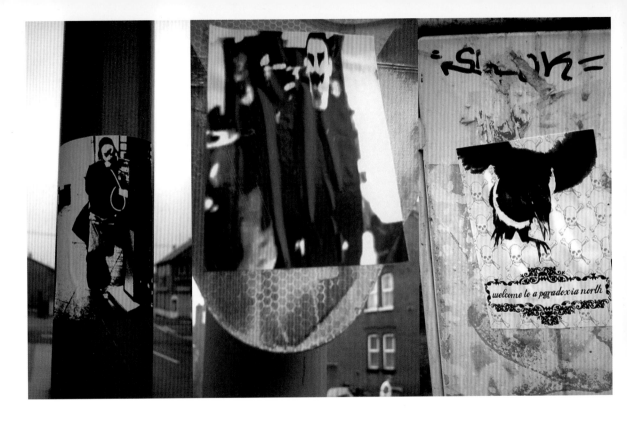

Moe:nipulation | U.K.

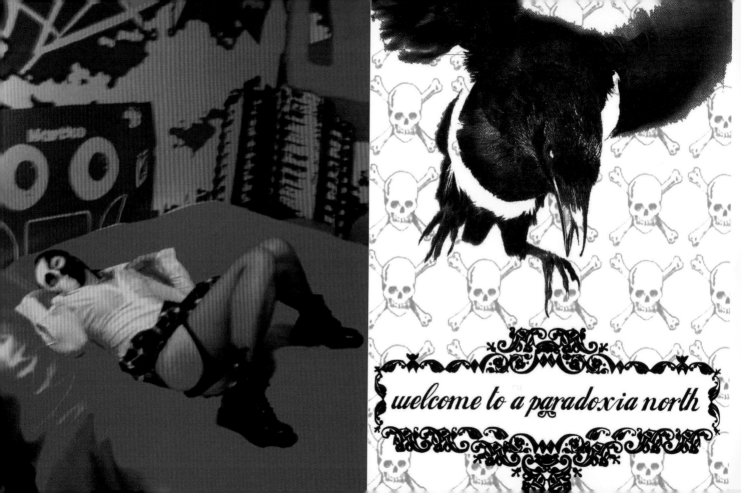

welcome to a paradoxia north

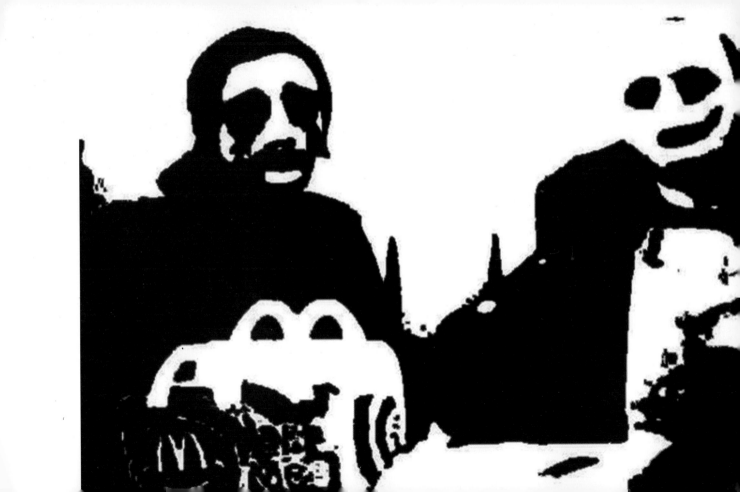

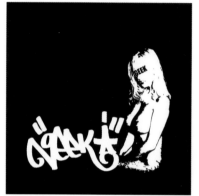

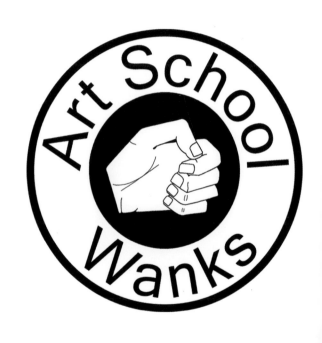

geekstar || Chris Hewitt | U.K.

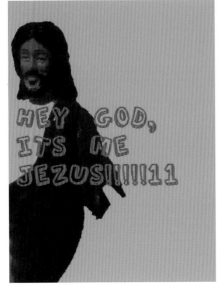

Muppy || Mal | U.K.

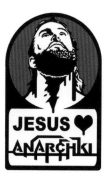

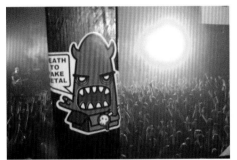
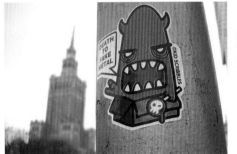

Kid Scribbles | U.K.

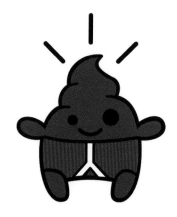
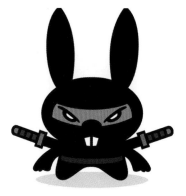

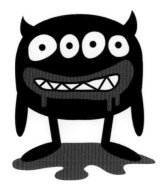

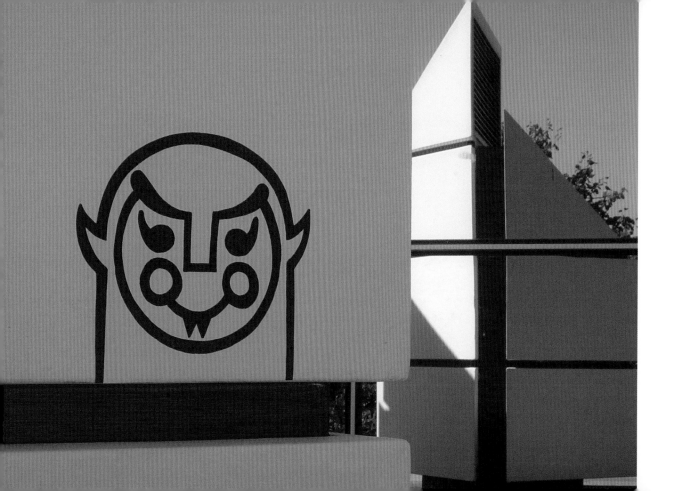

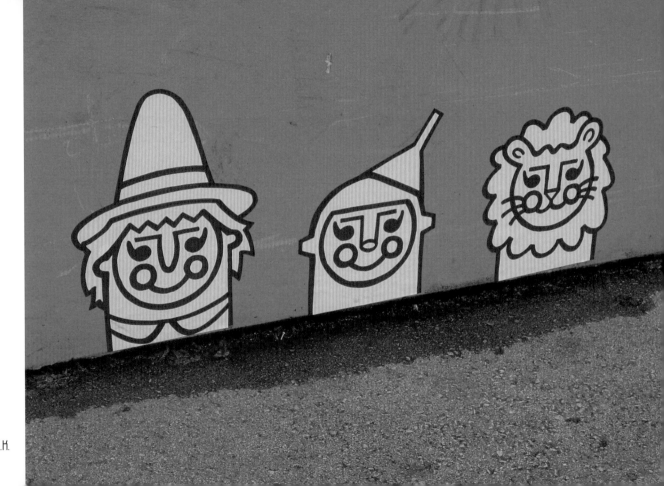

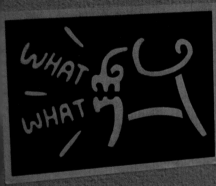

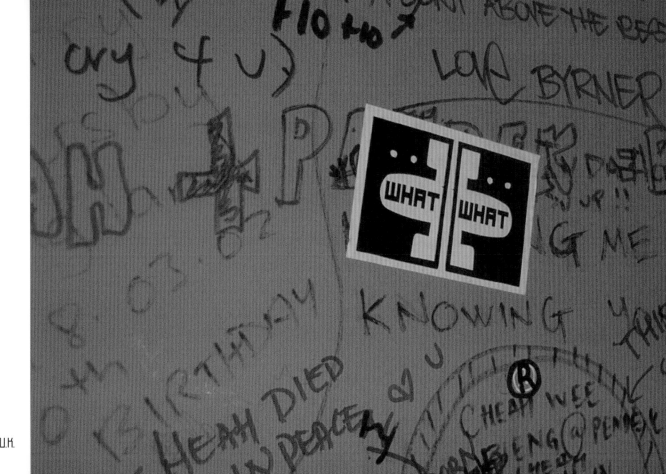

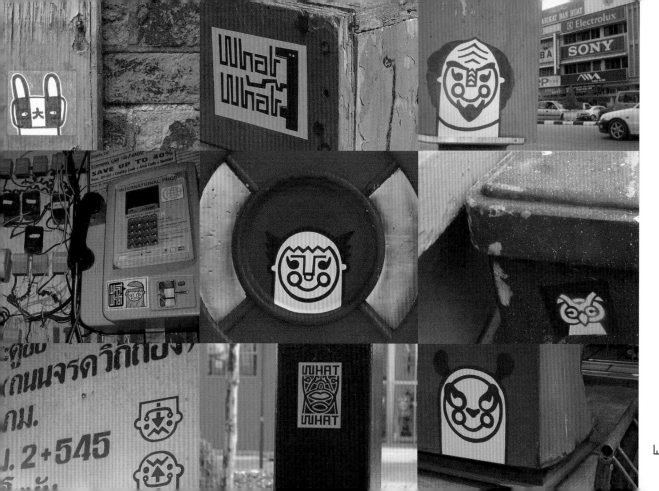

What What | U.K.

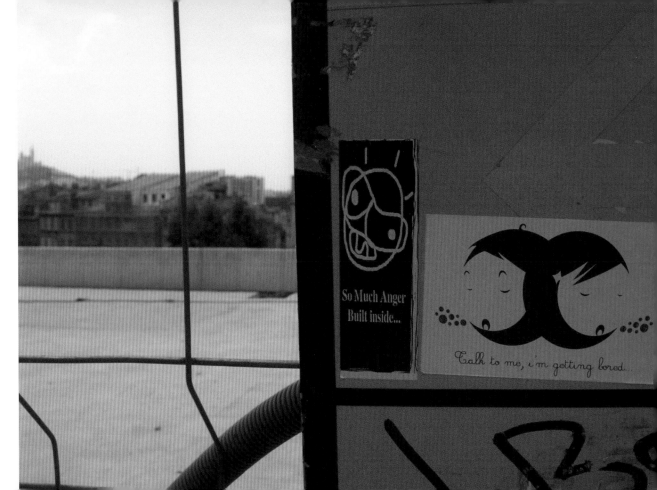

So Much Anger
Built inside...

Talk to me, i'm getting bored.

Ewos_one I U.K.

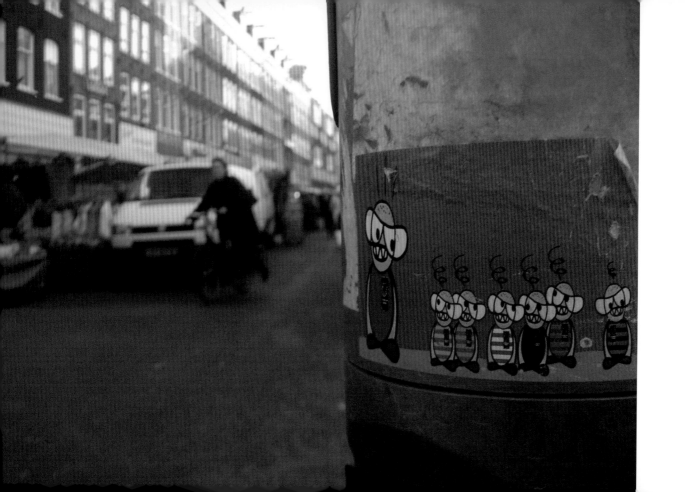

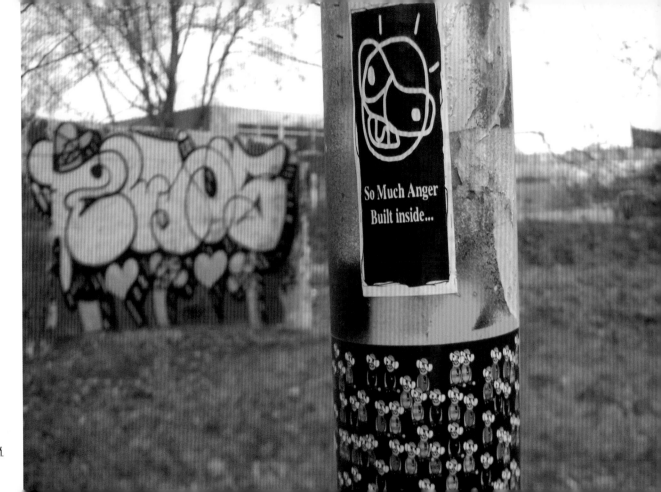

So Much Anger
Built inside...

Ewos_one I U.K.

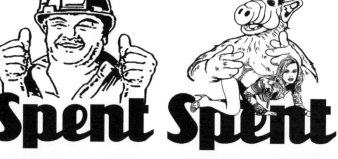

Spent Spent

Jay Loaring || Hutch ||| Spent | U.K.

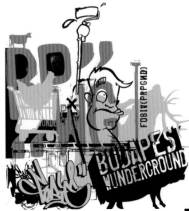

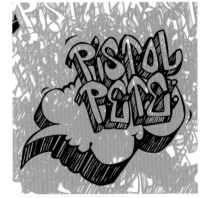

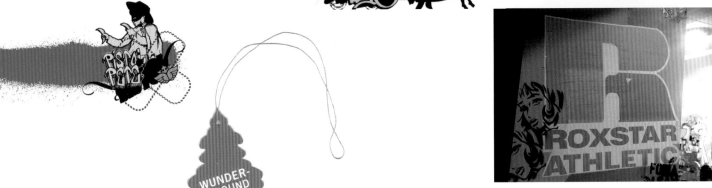

Fobia | Hungary

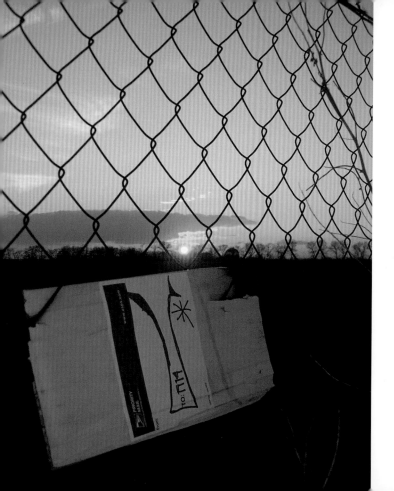

Kena | Ukraine

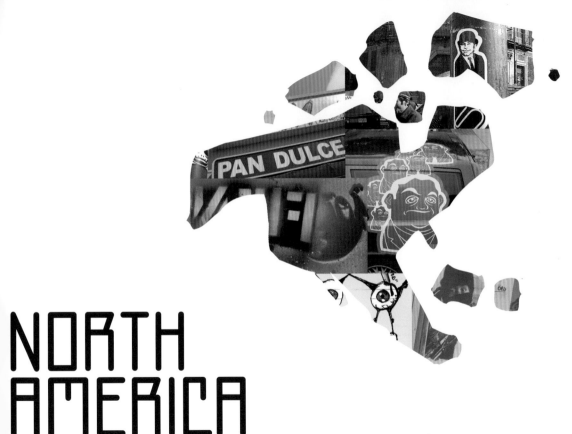

NORTH AMERICA

Canada

U.S.A.

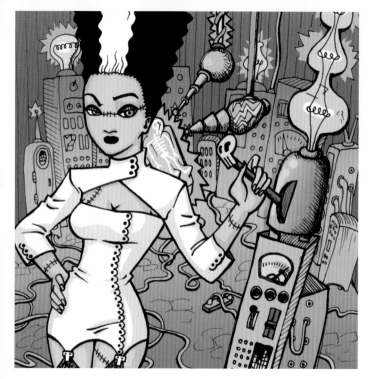

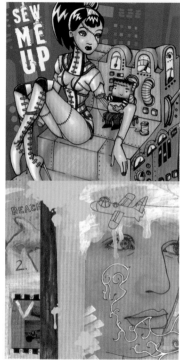

Rheanna | Canada

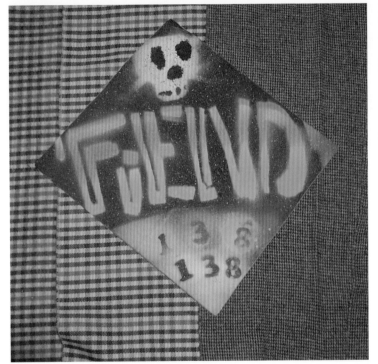

Adam Tammer | Canada

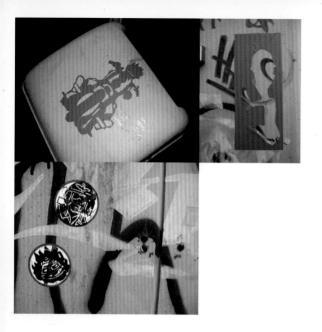

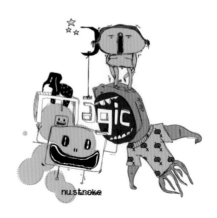

nu.stroke

Leandre Rudy II Posterchild I Canada

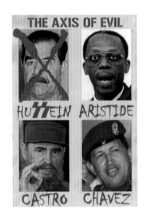

Alex Cuadra || Jen | U.S.A.

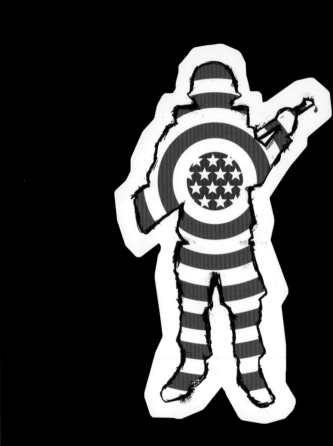

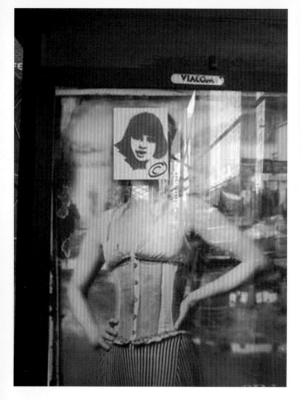

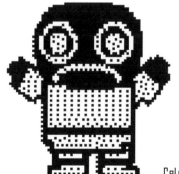

Celso Trevino II Movieegoogans I U.S.A.

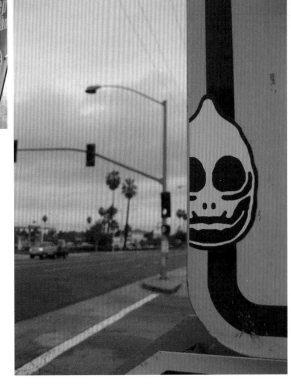

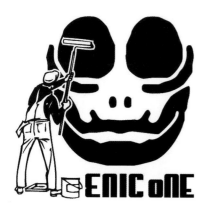

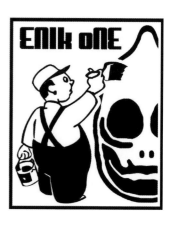

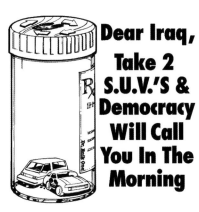

Dear Iraq, Take 2 S.U.V.'S & Democracy Will Call You In The Morning

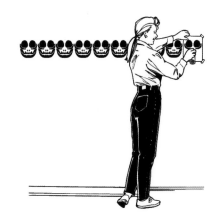

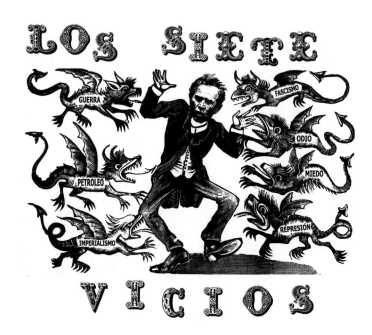

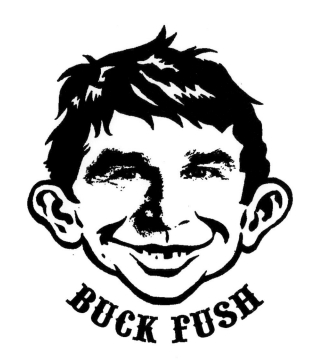

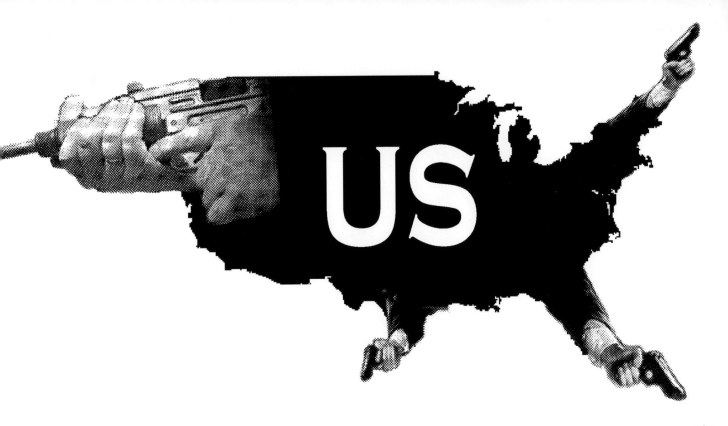

Patrick Piazza | U.S.A.

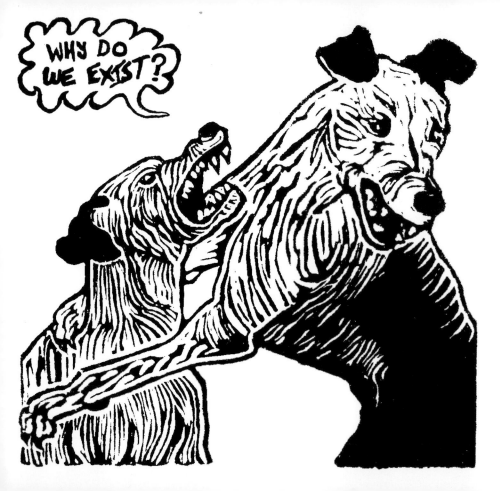

Patrick Piazza | U.S.A

Walt History

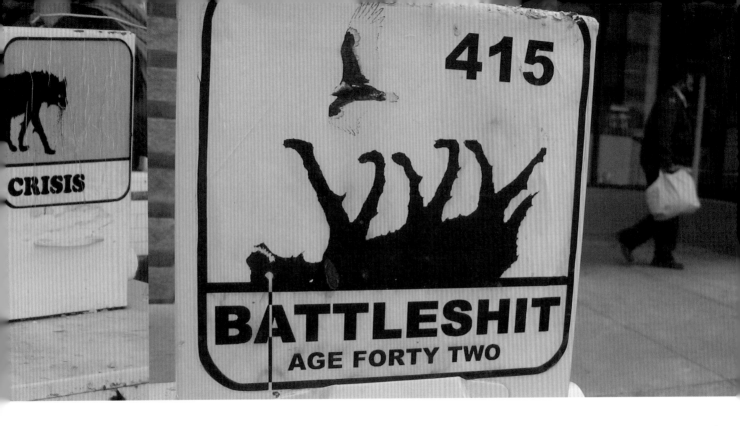

CRISIS

415

BATTLESHIT
AGE FORTY TWO

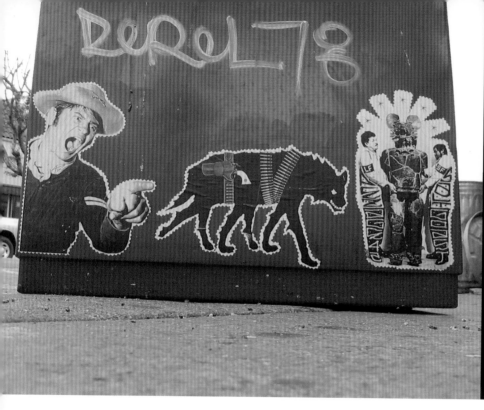

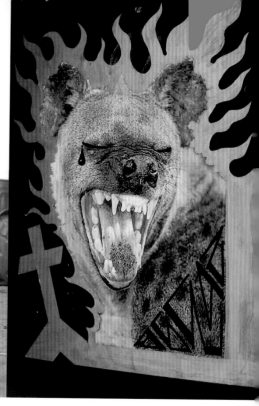

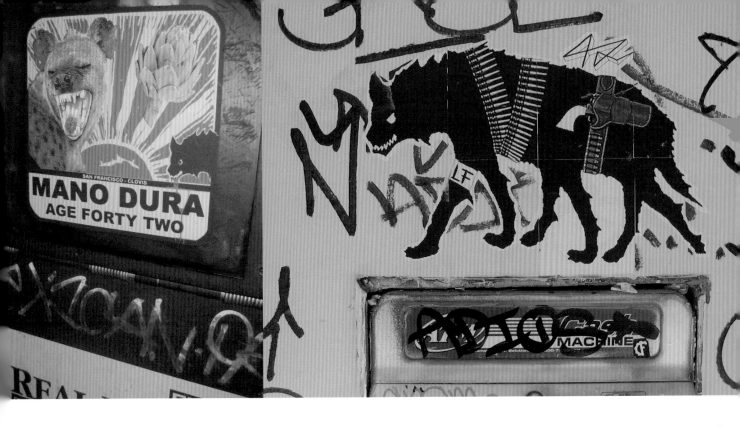

MANO DURA
AGE FORTY TWO

SAN FRANCISCO - CLOVIS

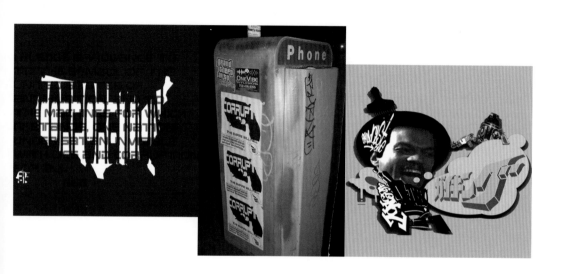

Lando | U.S.A.

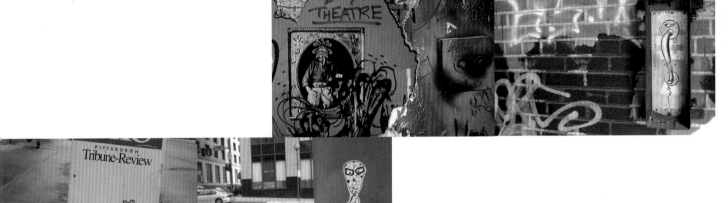

Emu || Spluter | U.5.A.

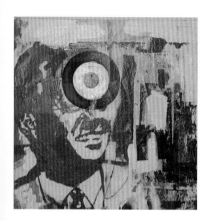
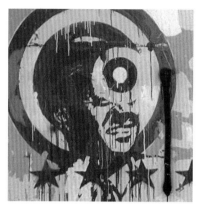
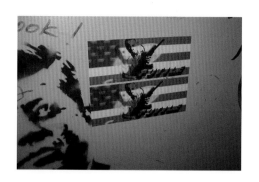

Fuse | U.S.A.

Proj Moustache | U.S.A.

Proj Moustache

Gomez Bueno | U.S.A.

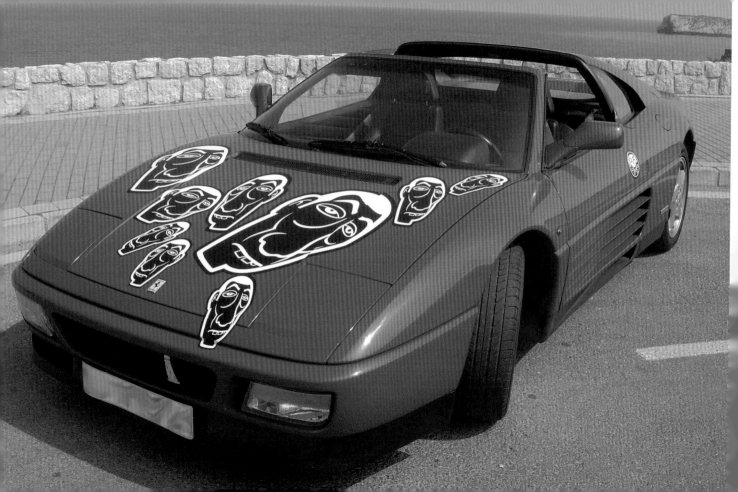

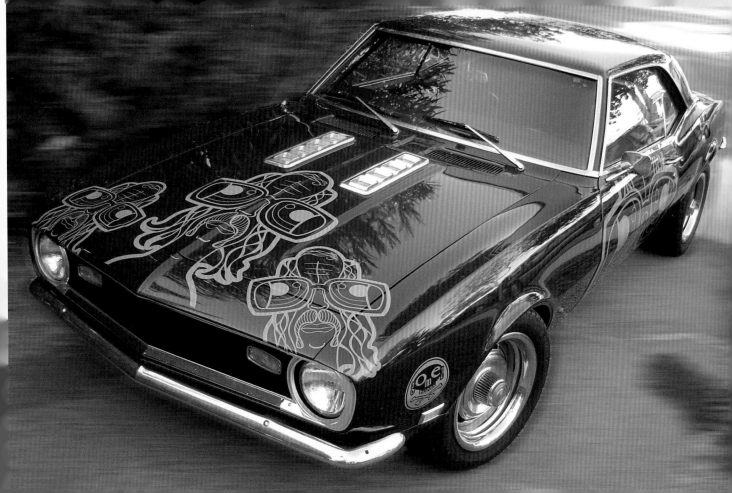

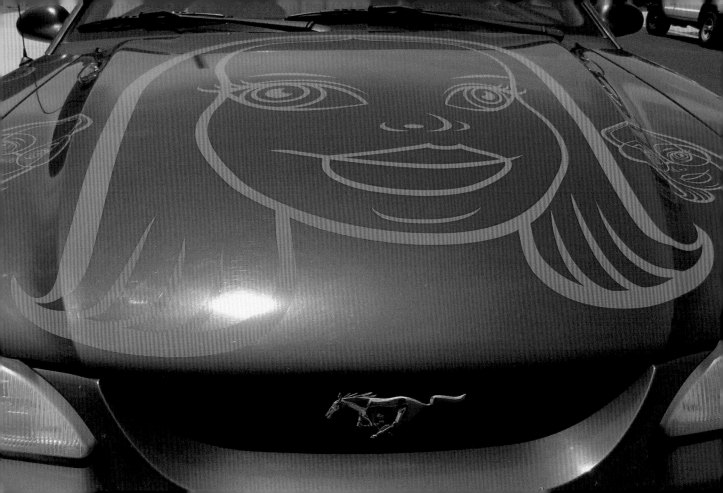

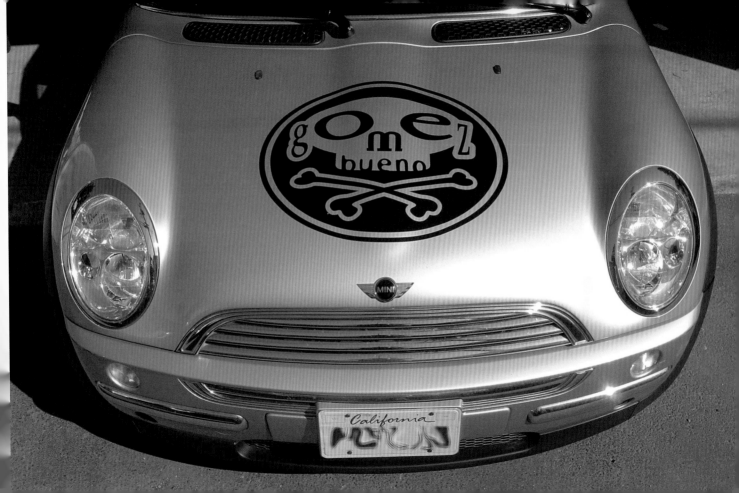

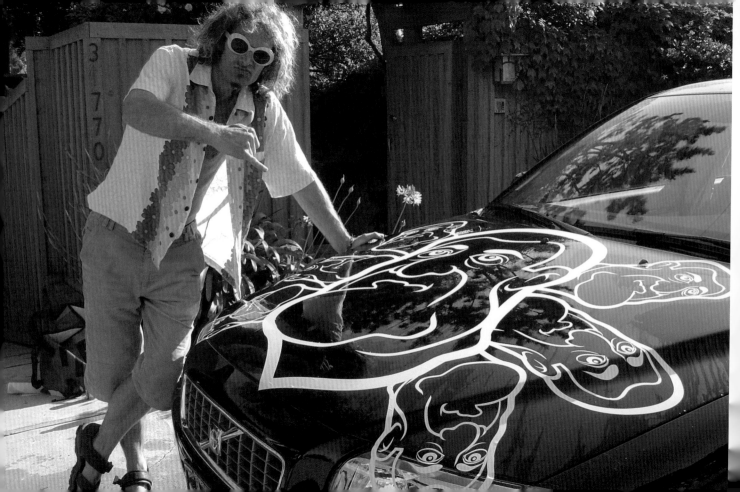

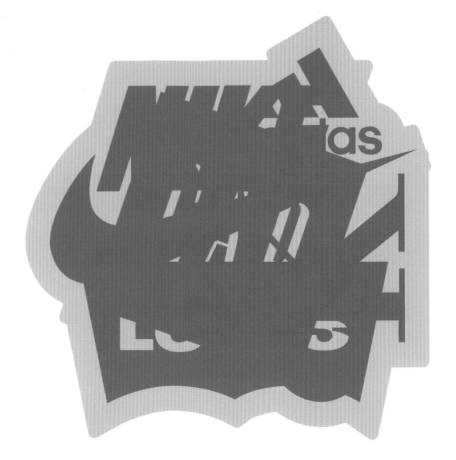

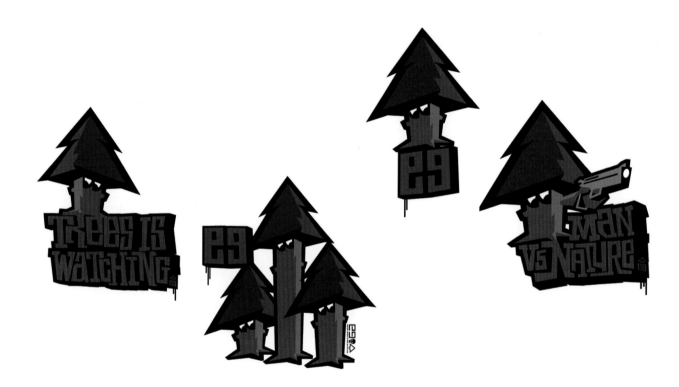

Shel M. Tiffany | U.S.A.

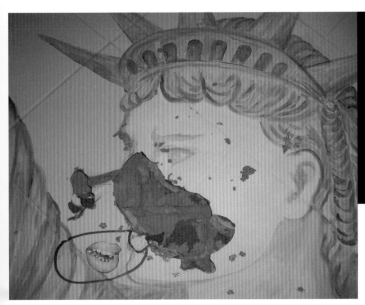

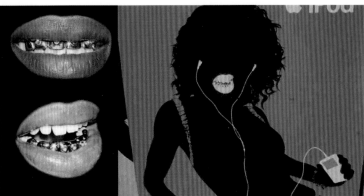

Zachariah | U.S.A.

yo soy.

CONTRIVED POP CULTURE REFERENCE HERE

visual narcotics
20mg.com

Frsh:aer ‖ 20mg ǀ U.S.A.

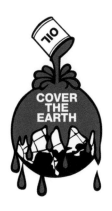

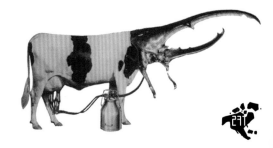

PigWolf II Michael Baker III Matt Forderer I U.S.A.

WATCH TV
FUNKY MEDIA

FUNKY MEDIA
listen to music

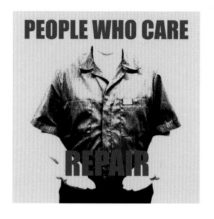

PEOPLE WHO CARE
REPAIR

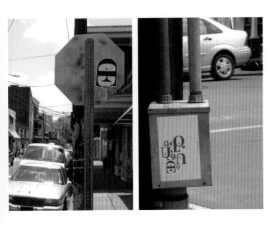

ASSOCIATEDCONTENT.COM
SUBMIT

witness

Kenneth Robin II Leonardo II Witness I U.S.A.

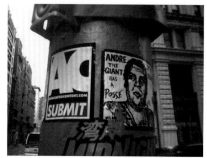
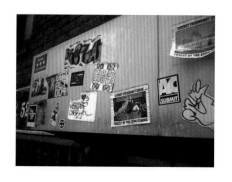

Luke | U.S.A

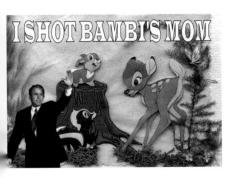

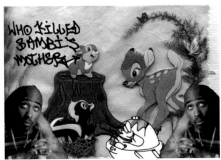

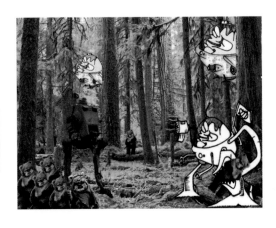

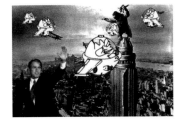

Plasma Slug | U.S.A.

The Reaps | U.S.A.

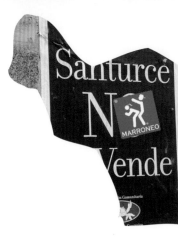
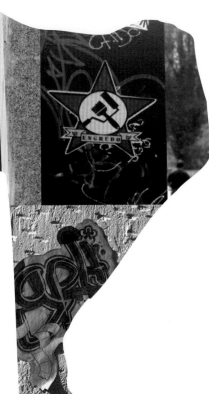

LATIN+ SOUTH AMERICA

Argentina

Brazil

Chile

Mexico

Puerto Rico

Venezuela

 280

Fernando Mello | Brazil

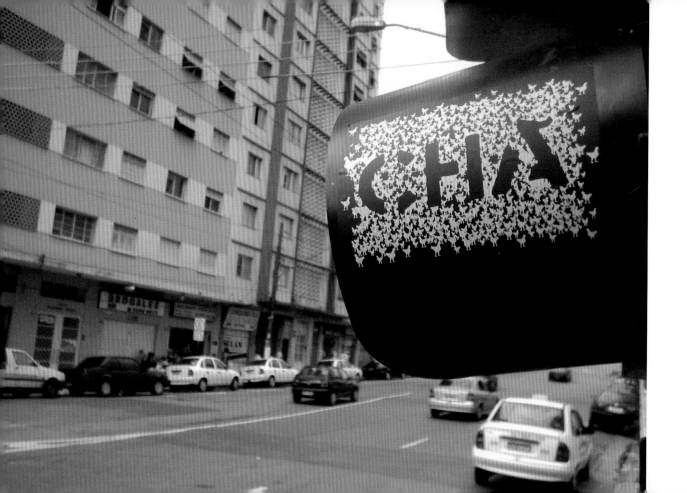

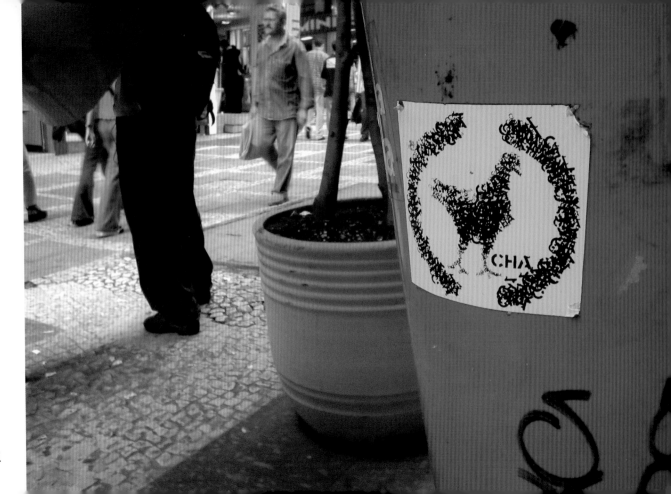

Cha | Brazil

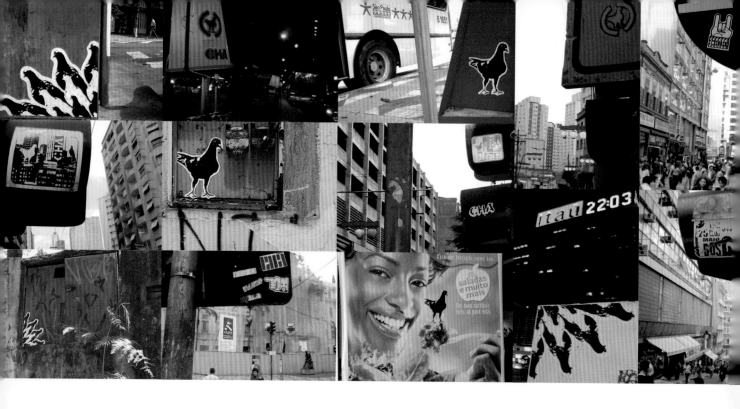

RAY ME

FISH ME

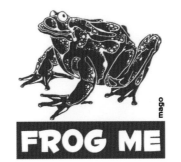

FROG ME

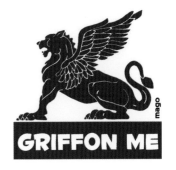

GRIFFON ME

MaGo | Brazil

285

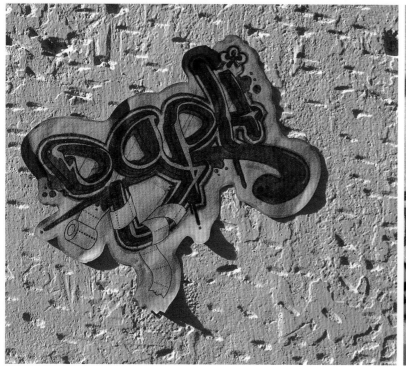
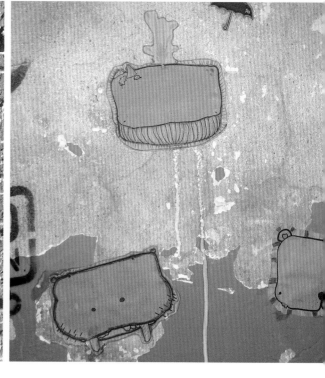

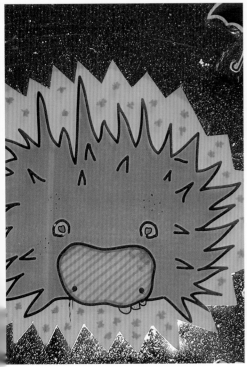
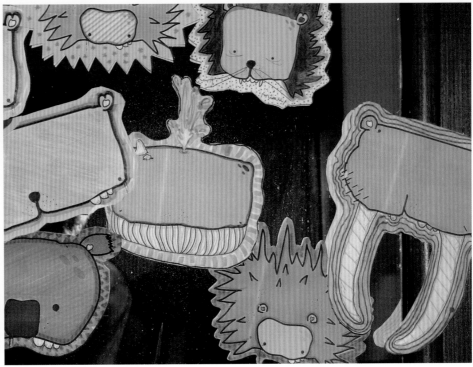

terrorizer

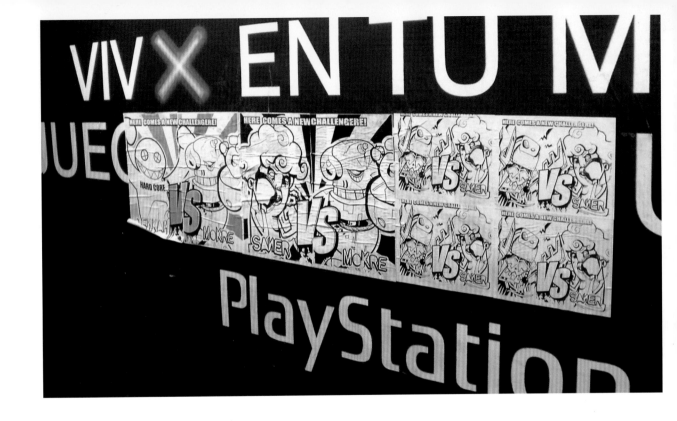

Eduardo Moreno | Mexico

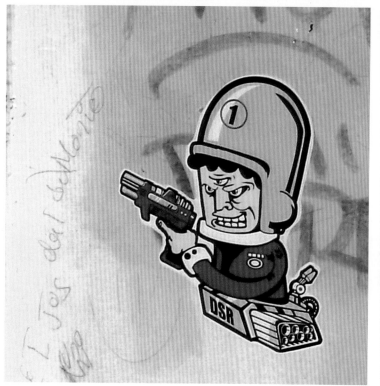
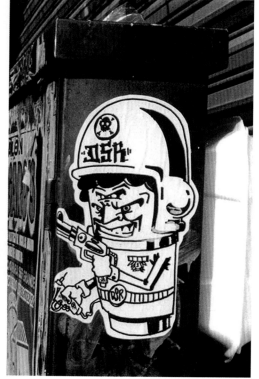

Saner | Mexico

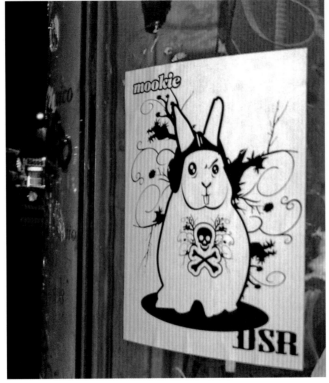

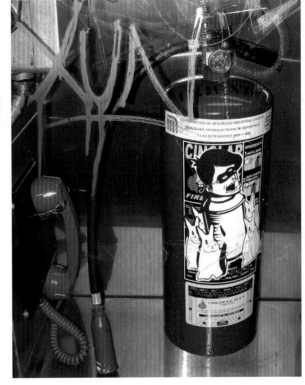

Mookiena | Mexico

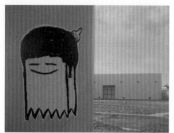
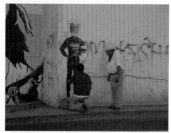

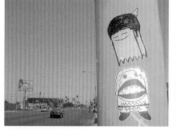
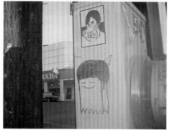
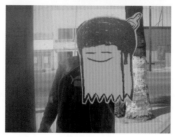

Stoks | Mexico

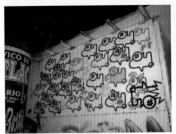

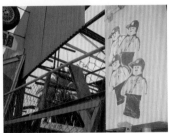
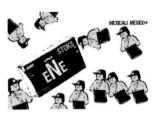

Jet II Stoks I Mexico

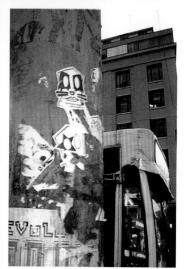
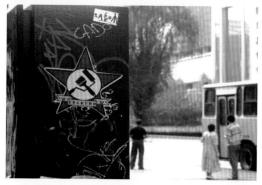
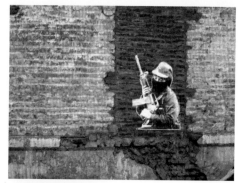
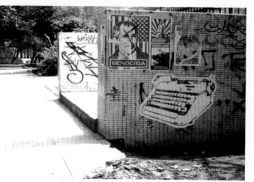
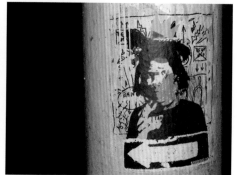

 294

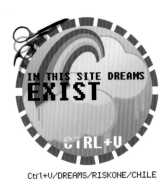

Ctrl+V/DREAMS/RISKONE/CHILE

Riskone | Chile

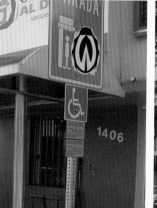
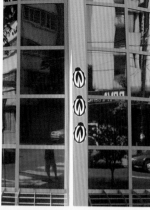

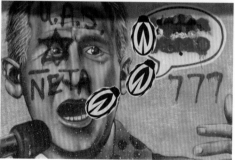
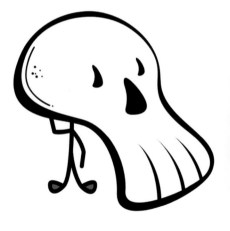

Wewex | Puerto Rico || Luispa | Venezuela

Lintpelusa | Venezuela

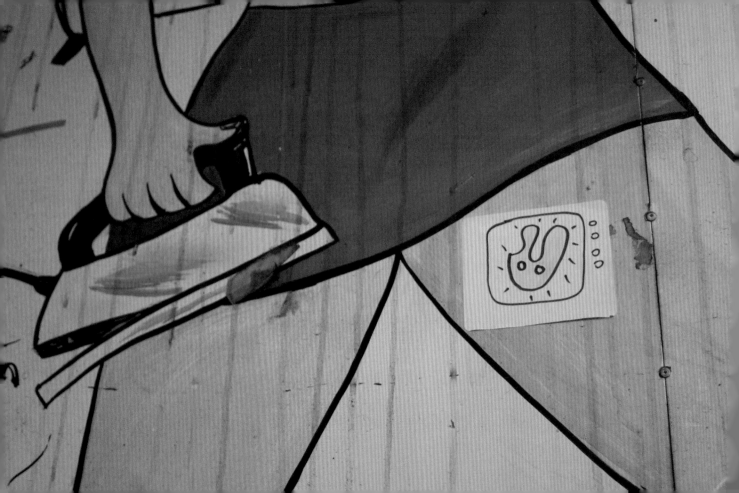

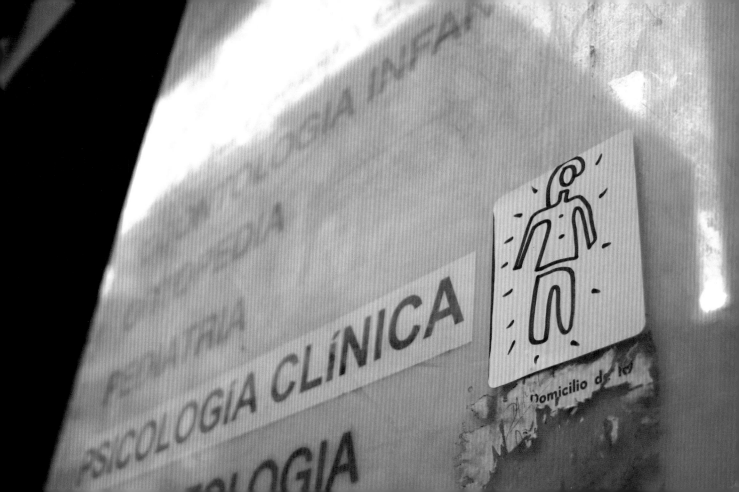

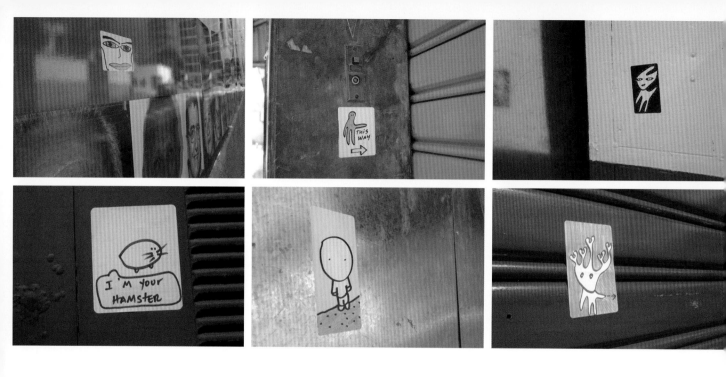

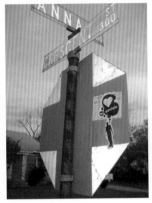
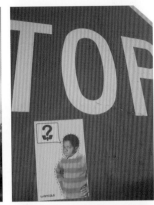

Wancalo ll Peephole l Venezuela

 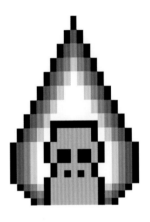

Hmto ccs | Venezuela

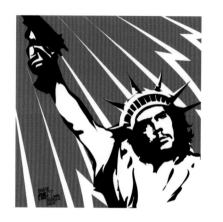
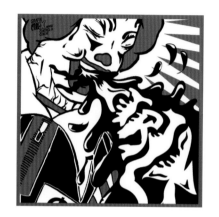
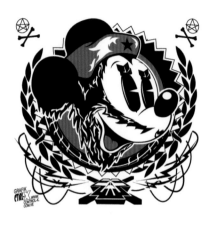

Daniel Gavotti | Venezuela

Carla Ly | Venezuela

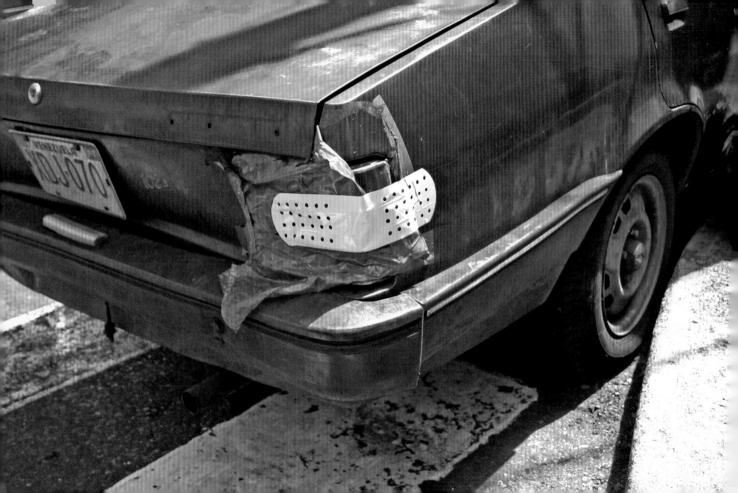

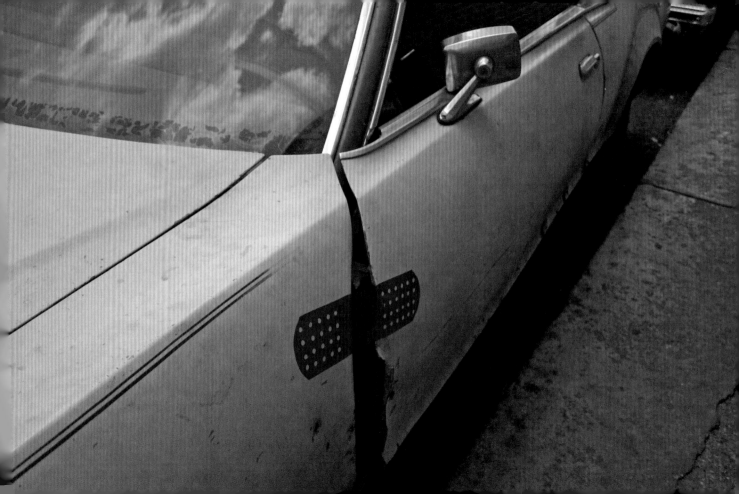

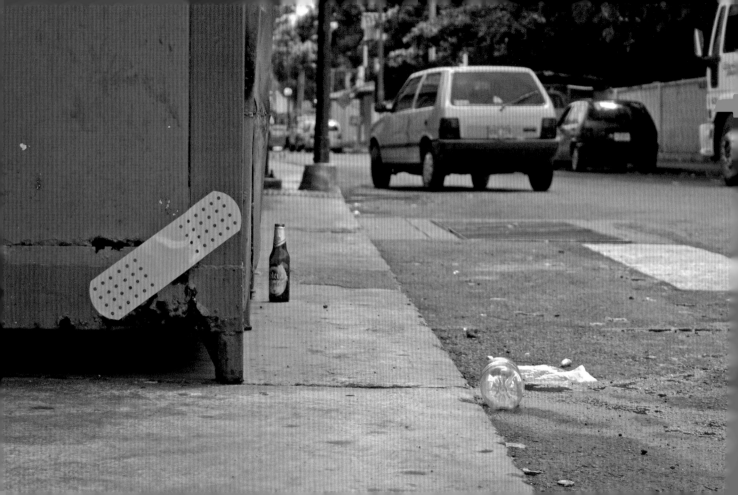

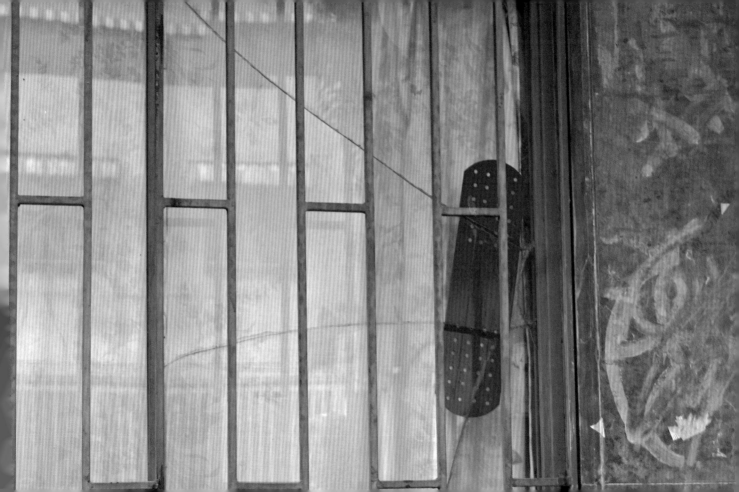

and the
winners
are:

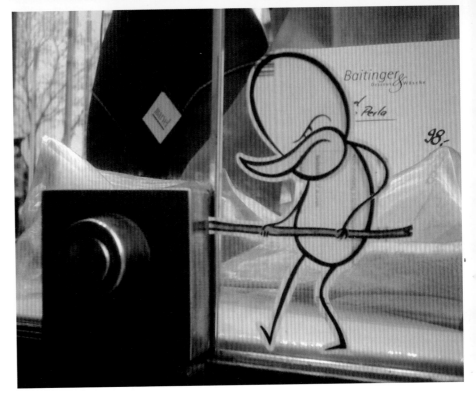

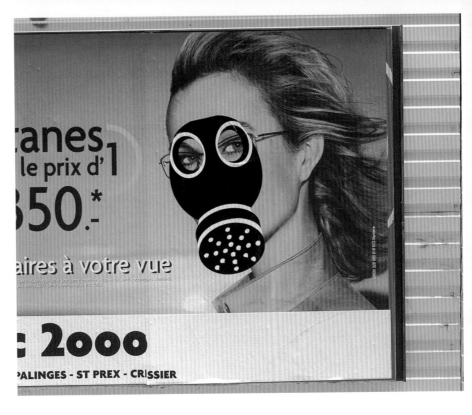

everything is true, be paranoiac

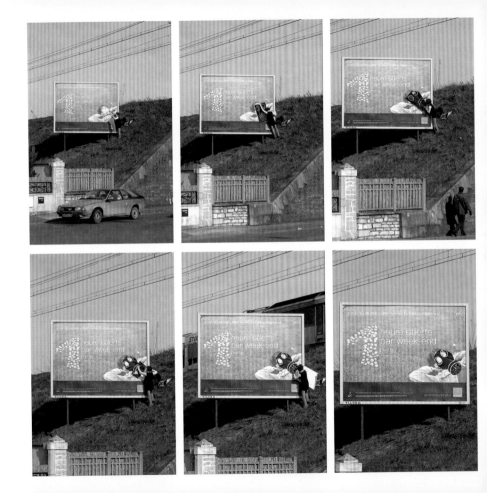

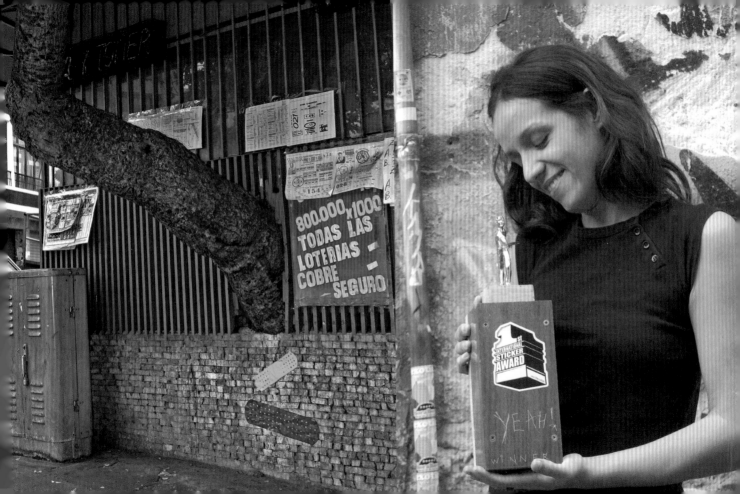

stickeraward.net is a project by rebelart.net and stickma.de

Edited by Andreas Ullrich, Matthias Marx, Matthias Müller
Layout and design by Matthias Müller, flyermueller@stickma.de
Design assistance by Andreas Grahl, Marcel Tasler
Font design Foo-Reinhart Light by Matthias Marx, www.FooFonts.com
Additional illustrations by Matthias Müller
Logo and Cover design by Alexander Dorn
Trophy design by Marcel Tasler

Prologue and Essay by Andreas Ullrich
Translated by Andreas Ullrich

Production management by wildsmile studios, Dresden, Germany

Published by Die Gestalten Verlag, Berlin 2006
Printed by Preses Nams, Riga
Made in Europe

ISBN 3-89955-151-6

Bibliographic information published by Die Deutsche Bibliothek.
Die Deutsche Bibliothek lists this publication in the Deutsche Nationalbibliografie; detailed bibliographic data are avail-
able in the Internet at http://dnb.ddb.de.

For more information please check: www.die-gestalten.de

Imprint